IMAGES
of America

RUMSON
VOLUME II

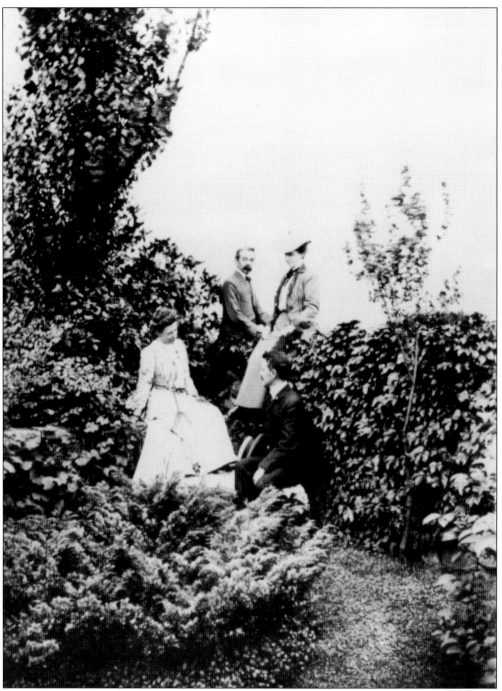

Mr. and Mrs. Edward Dean Adams are seen with an unidentified couple on the grounds of their estate, Rohallion. Readers are treated to spectacular views of their magnificent property thanks to Blake G. Banta's preservation and the generous loan of an Adams family album.

IMAGES
of America

RUMSON
VOLUME II

Randall Gabrielan

ARCADIA
PUBLISHING

Published by Arcadia Publishing
Charleston SC, Chicago IL, Portsmouth NH, San Francisco CA

Printed in the United States of America

Library of Congress Catalog Card Number: 2003107158

For all general information contact Arcadia Publishing at:
Telephone 843-853-2070
Fax 843-853-0044
E-mail sales@arcadiapublishing.com
For customer service and orders:
Toll-Free 1-888-313-2665

Visit us on the Internet at www.arcadiapublishing.com

This book is dedicated to Michael Steinhorn, friend, loyal supporter, and major enthusiast of Rumson history. Michael's candor and inimitable personal style make conversations, whether on a favored topic, Rumson history, or any other subject for that matter, stimulating and enjoyable. He carries on the tradition of the William Everhard Strong Rumson Road estate, living with his wife, Donna, and their children, Adam and Lauren, in its carriage house, the only remaining estate structure with intact integrity. (Photograph by Susan Barr.)

Contents

Acknowledgments 6

Introduction 7

1. Rumson Bluff and the Shrewsbury Shore 9

2. Rumson Road 27

3. Rohallion 51

4. Oceanic and East Oceanic 67

5. The Bordens 85

6. Around Town 101

Acknowledgments

Blake G. Banta's loan of an Adams family album provided most of the images for chapter three. Its depth and richness may contribute to another lengthy look if a third volume is published in this series. My deepest thanks and appreciation, Blake.

The Bordens have long-contributed to Rumson in significant ways. The images for chapter five were graciously lent by members of the family.

Friends and collectors John Rhody and Michael Steinhorn (see p. 4) can be counted on to support a project before it begins. My ongoing and heartfelt thanks to them.

Robert Zerr, a retired chief of police, has long served Rumson, and he continues to do so through his assistance with this book. The interest and number of his images merit special thanks, and mention away from his usual place on an alphabetical listing.

Photography Unlimited by Dorn's is expanding their vintage collection—all available at their Red Bank shop—to cover all of the area's towns. My thanks and appreciation to Kathy Dorn Severini for finding, providing, and printing from this magnificent resource.

Thanks to Maryfaith Radcliffe, garden consultant, for her advice and review of horticultural matters.

My sincere thanks to all lenders, whose generosity demonstrated that a collection of collections can provide the depth and breadth that make Rumson exciting to view repeatedly, including: Olga Boeckel, Edith Borden, Tina Braswell, Alfred Brighton, Kevin "Buzz" Byrne, Bobbi Campbell, Joseph Carney, Joseph Eid, Gail Hunton, Donna and David Kreidler, Mr. & Mrs. Q.A. Shaw McKean Jr., Virginia Mohan, the Monmouth University Library, the Monmouth County Historical Association, Thomas Moog, George Moss, the late John J. Mulhern, Sally O'Brien, Thomas O'Mara, Suzanne Parmly, the Red Bank Public Library, Alice Robinson, Carol Scherling, Robert A. Schoeffling, Mimi Sherman and the Merchants House Museum, Patti Low Stikeleather, Marylou Strong and the Seabright Lawn Tennis and Cricket Club, Frank Trafford, Gail Mazza Vicars, Keith Wells, and Marilyn Willis.

The Many Faces of Rumson

The image conveyed by late-nineteenth-century writers has long remained as Rumson's prevailing public face. Gustav Kobbe in his 1871 *Jersey Coast and Pines* observed "The roads and walks throughout Rumson Neck are kept in admirable order, and on all sides there is evidence that it is controlled by people of wealth and taste, the improvements made by summer visitors having enhanced rather than destroyed the natural beauty of this superb penninsula." Rumson Road was by then one of the most famed country drives in America. Kobbe also noted that "Ridge Road . . . has become one of the favorite drives on the coast. The view is particularly fine from the tower of the house on Bingham Hill" (see p. 105).

Rumson's early settlement stems from its coastal location, a few yards from the Atlantic Ocean, separated by a barrier beach once (and perhaps in the future) penetrated by inlets. One wonders if Rumson was active as the water outlet for Shrewsbury, a role suggested by the old Black Point-Shrewsbury Road (p. 104). It is an issue meriting further research.

Rumson was little known to the outside world during much of its first century and a half of existence. Its rich soil was farmed and its waterways fished. The farms were of strong appeal during the post-Civil War country estate movement. Pictorial evidence of the fine houses built then on the farms are liberally represented in this and its companion predecessor volume. However, few reminders of early Rumson farm life appear to have survived. The maritime community is also under-represented in these books.

The growth of steamboat travel expanded the world's view of Rumson. The 1845 erection of Thomas Hunt's Pavilion Hotel provided a resort face to the region; Hunt also ran a steamboat to transport guests. His building of a church and his sale of lots in 1853 would spur the creation of year-round activity, providing a face of permanence and a town center.

To a large extent, however, Rumson remained a seasonal community until little more than sixty years ago. Its estates were summer homes; their owners returned to nearby cities in the fall. Most of the large staffs for the houses and grounds remained in town, building modest houses on small lots, providing a less visible face—but reliable substance—to a town usually viewed from the estate perspective.

The author has attempted to portray these varied faces in balance, but has had to use available material. He hopes reader interest will maintain the high level afforded the predecessor volume and justify a third book. Loans of pictures are welcome and encouraged. Please feel free to contact him at 71 Fish Hawk Drive, Middletown, NJ 07748, or at 732-671-2645.

Errata (Volume I)

page 16 top—The architect's name is spelled Keely. One hopes his plans were clearer than his signature, which had virtually no distinction between the "e" and "l."
page 32 bottom*—The occupant is the Woodward Realty Group.
page 36 bottom*—The owner's name is spelled Christianson.
page 39 bottom—The property's name is Riverfields.
page 53 top*—Two Edwin Stewarts were confused. The builder of this house was a major figure in the reinsurance business.
page 55 top—A Highland Avenue resident indicated the pictured stream is the creek north of that street, not the Rumson Waterway.
page 63 top*—The occupant is the furniture refinishing shop"Once Removed."
page 69 top—The view is the north side of Church Street, between Lafayette and Allen.
page 84 top*—A second initial is restored to the name of Matthew C.D. Borden.
page 95 bottom*—Borden was an arranger during his school years.
page 108 top*—The photographer's name is Christopher D. Chandler.
page 118 bottom*—The estate owner was Edward Dean Adams.
page 125 top—It appears that the Oceanic Hook and Ladder Company pictured was not Rumson's.

* These changes were made in the second printing of *Rumson*. There is no marking in the books to indicate later printings, other than the presence of these corrections.

One

Rumson Bluff and the Shrewsbury Shore

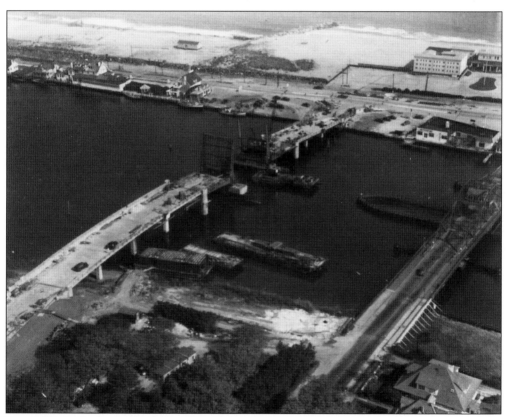

The 1870 bridging of the Shrewsbury River was one of the most important factors in the development of Rumson for country estates. The fifth and present Sea Bright-Rumson Bridge (at left) was completed in 1951. The earlier span was directly at the end of Rumson Road. Note the James Allgor house (see pp. 28–9) in the bottom right corner, at One Rumson Road, and the Sea Bright Beach Club (top) founded in 1895 by Rumsonians. (The Dorn's Collection.)

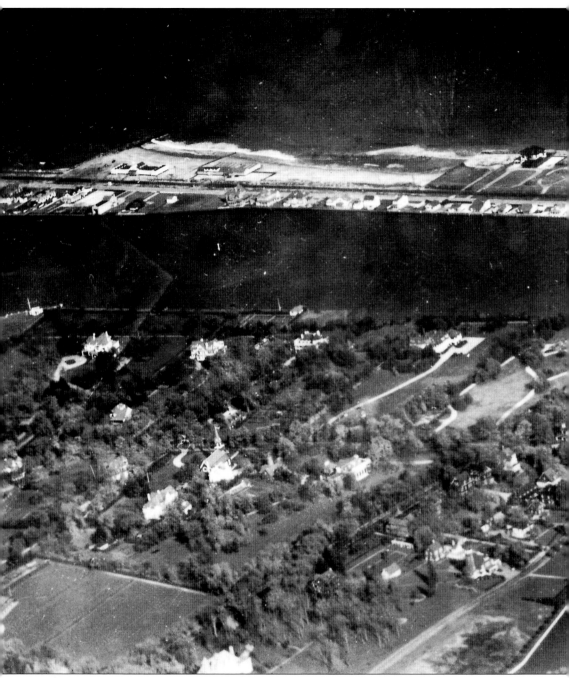

This *c*. 1940s aerial view of eastern Rumson shows the town before intensive development around Oyster Bay (bottom) and Sea Bright (top), with some important but no-longer-standing structures. Note the one remaining waterfront house (near the fold), adjacent to two vacant lots with driveways—reminders of former neighbors. The Sea Bright Beach Club is above the bridge, while the former railroad station is between the two structures. The Peninsula Hotel, destroyed by fire in October 1986, is at right. Holy Cross Roman Catholic Church (with steeple) and

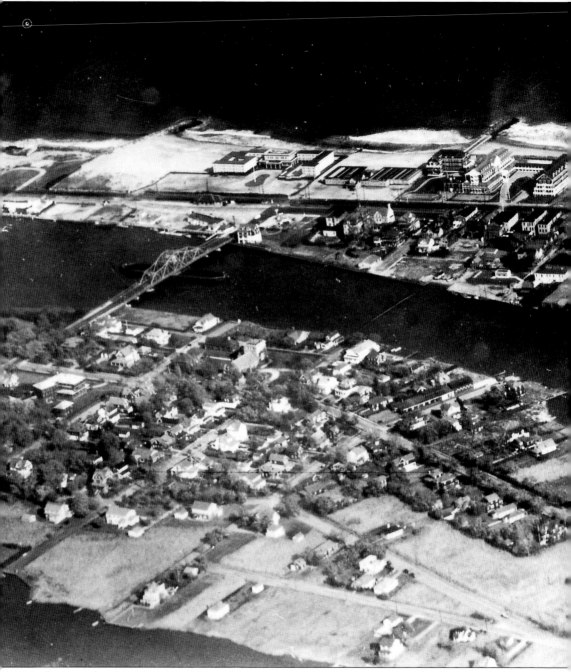

its former school (with columns) are the most recognizable structures on the Rumson shore at left. The square tower of St. George's P.E. Church and the L-shaped roof of the former Rumson Hotel (to the right of, and under the bridge, respectively) are recognizable at right. The circular driveway absent a house (left of the bridge) marks the approach to the present span. (The Dorn's Collection.)

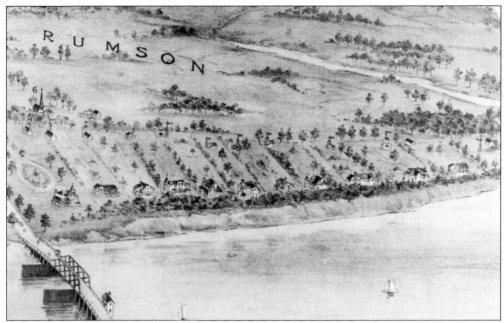

The Rumson Bluff is seen on an undated picture map of Sea Bright, *c.* 1895. The last of the Ward Avenue houses, J.C. Neeser's home was built in 1891 (right of the bridge). For other related views see p. 14 of *Rumson Vol. I,* and the circular driveway on p. 10 of this book. Holy Cross is adjacent to the 6 at left. The pattern of the east side of Ward Avenue development is evident—service buildings near the street and houses near the river. The crude drawing of the first bridge is probably accurate and a better representation than the open span pictured on p. 9 of *Rumson Vol. I.*

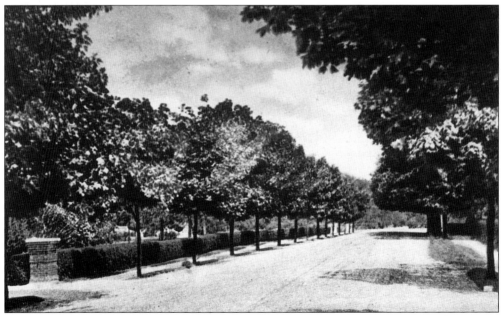

Ward Avenue was a pleasant tree-lined thoroughfare *c.* 1910 and remains so. (Collection of Michael Steinhorn.)

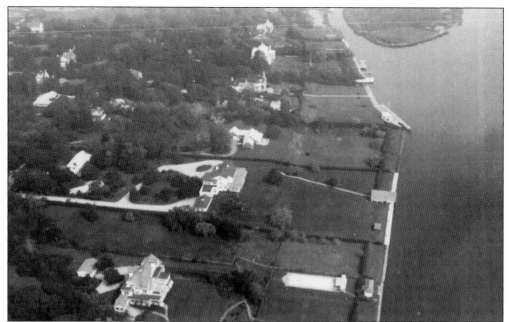

Ward Avenue is viewed c. 1950 north from the Sea Bright-Rumson Bridge. Perhaps the most prominent house is in the center, the one with the octagonal tower, also shown on p. 14. Above it is the Charles A. Peabody house (*Rumson Vol. I*, p. 20), demolished in 1997. On the right is an uninhabited island, now named for Msgr. James Francis Kelley, recent owner of the Peabody house, who donated the island to the borough of Rumson. (The Dorn's Collection.)

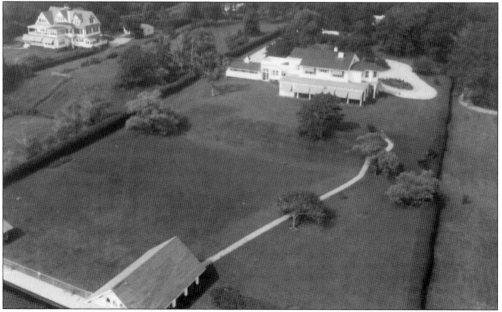

This c. 1950 aerial of 23 North Ward Avenue is the Robert Lenox Belknap house, built in the 1870s soon after the opening of the Sea Bright Bridge. It has been changed often, including restoration of fire damage. A second-story balustrade and first-story columns are changes since this image was made.

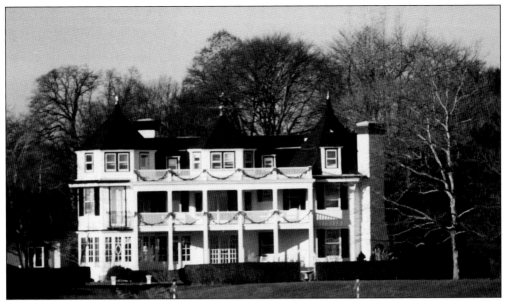

The Stick Style origins of 17 North Ward Avenue may be seen on p. 18 of *Rumson Vol. I*. This 1990 image of the Colonial Revival remodeling remains intact, but a large kitchen wing was later built on the south (at left). The house was associated with Major Bowes, owner from 1938 until his death in 1946, the noted radio personality who broadcast many of his Amateur House programs from here.

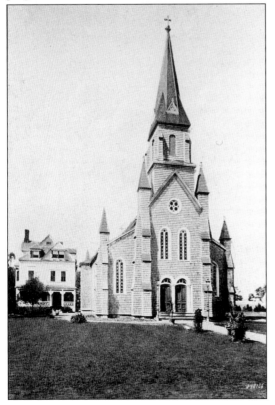

Holy Cross Roman Catholic Church at 30 Ward Avenue was designed by Patrick C. Keely of Brooklyn, built in 1885, and dedicated in 1886. Initial use was delayed by significant damage caused by lightening striking the new church in May. The church has been expanded, although its integrity is faithful to this *c*. 1905 postcard image. The rectory, probably built soon after the church, no longer stands, replaced by a 1977 structure on the north.

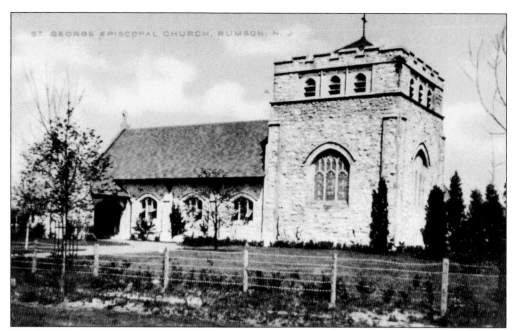

The major structural change to St. George's-by-the-River Protestant Episcopal Church was the 1950s removal of the south wall, seen here on a *c*. 1910 postcard, and the erection of the chantry, a smaller place of worship, aside and open to the nave. The east-facing tower is now the site of the Mary Owen Borden Memorial Carillon (*Rumson Vol. I* , p. 121). (Collection of John Rhody.)

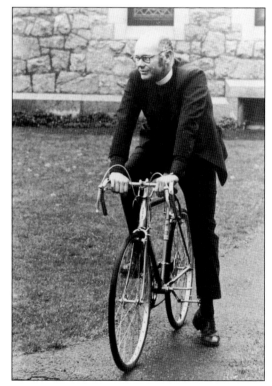

George Willis, then curate of St. George's, is seen in 1972 near the time he was departing for a position in Newark, New York. The Reverend Willis returned to St. George's as rector in 1975. He recalled recently that his bicycle riding days were some time in the past, as he prefers more conventional transport now.

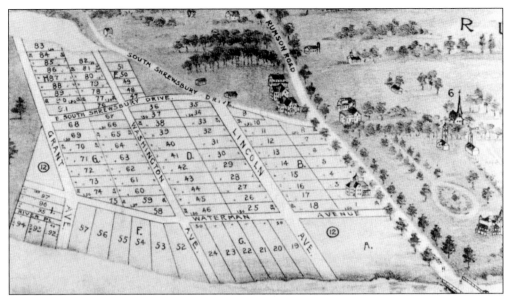

William W. Conover of Red Bank was one the largest real estate investors of his time. Around 1890, he purchased this tract, located south and west of Rumson Road and the Sea Bright Bridge, and thus became the source of its early name, Conover Park. Here the park is seen on a c. 1895 map of Sea Bright. The Land and Loan Company bought much of the property in 1906 for development. The name changed to Conover West Park and then West Park, in time being applied to a wider area near the eastern stem of the Shrewsbury River shore.

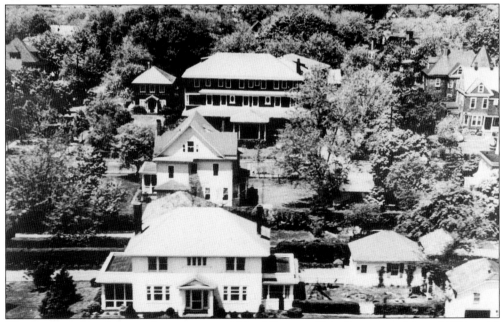

The Rumson Hotel (seen close-up on p. 122 of *Rumson Vol. I*) is viewed in a 1937 aerial photograph. It was a smaller structure when moved from Sea Bright in December 1914; the top floor and rear wing were added later. At front are the buildings facing the river bank. The garage to the Allgor house is at right. A 1955 press account indicated the hotel's twenty-six rooms accommodated fifty people, while the dining room seated 125.

The Rumson Hotel Annex can be viewed on the bottom left of p. 16, south of the main structure. These images date from Mary H. Molloy's 1937 purchase. Many of the hotel's antique furnishings, Oriental rugs, and sporting prints came from her Trenton home.

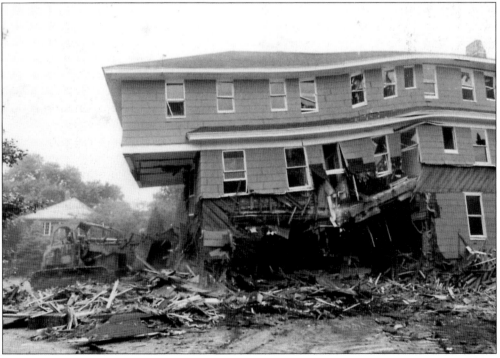

The Rumson Hotel's useful existence was ended by the 1980s. Having become more valuable as housing lots, it was demolished on July 11, 1984.

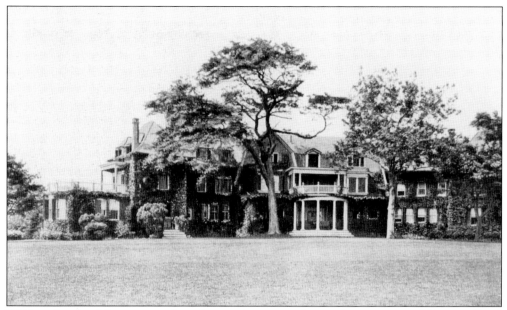

William Everhard Strong owned a substantial estate at the northwest corner of Rumson Road and the Avenue of Two Rivers when he began, in 1895, to assemble a large amount of acreage on the Shrewsbury River around Pollys Pond. Local contractor Pearsall and Bogle built this enormous Colonial Revival house there in 1895–96, architect unknown. Dr. John A. Vietor owned it from 1921 to 1926, calling it Willow Brook Farm, a name later applied to Dalton's house (p. 49).

Alice Robinson recalled post-World War II West Park as an area of simple and affordable houses. She liked its pleasant neighborhood quality. She was alluding to the substantial rise in real estate values over the past three decades and a much more intensive use of the land, notably its waterfront.

Frederick Moog Jr., a long-time maritime enthusiast, was a commander of the Shrewsbury Power Squadron.

Frederick Moog Jr. built this house at 7 Oyster Bay Drive in 1956–57, doing much of the work himself. It was located on the former Strong rose garden, just to the south of the inlet on the right of p. 21. The house has been altered considerably, including a tower-level addition in the center and the construction of a wing extending from the west facade.

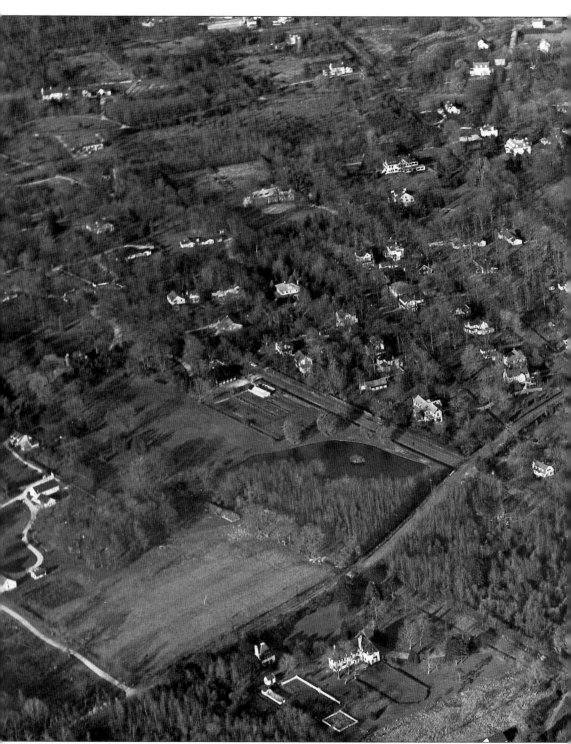

Shrewsbury Drive is the curved street in southeastern Rumson, near the body of water now Oyster Bay, formerly Pollys Pond. The promontory to the south (right) was known as Wrights or Strongs Point, for its former owners. It was sold by Edward Scudder in the 1940s

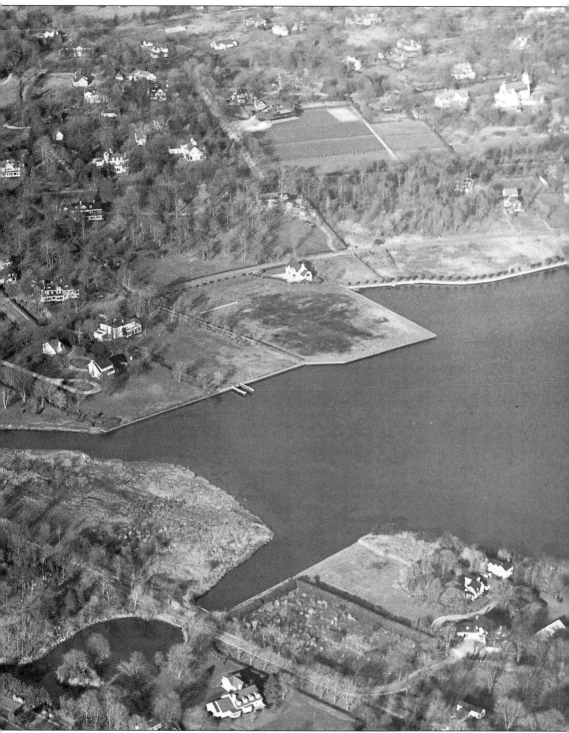

following the 1945 gift of the major part of his house to the Rumson Country Club, and was subsequently developed.

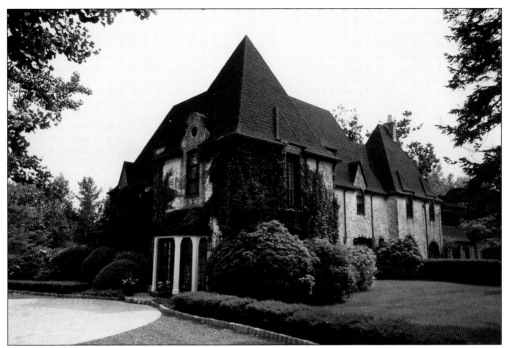

Newark architect Joseph Sanford Shanley bought 44 acres of the William E. Strong estate in 1927 on a plot bounded by Shrewsbury Drive on the north, the Avenue of Two Rivers South on the east, and the Shrewsbury River on the south. He designed a house in a French Norman style at the southwest corner of the two aforementioned streets for his mother.

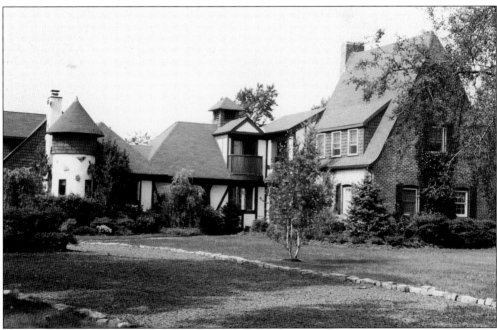

Shanley designed a second Normanesque house for his own occupancy at 8 Avenue of Two Rivers South, also built in 1928. His apparent plans to develop much of the plot were probably thwarted by the depression.

22

Gail Slingluff is seen in 1984 in front of her former residence at 16 Avenue of Two Rivers South. It is a third Shanley-designed Normanesque house from the 1928 period, this one built for his friend Thomas Adams. The house is little changed, although removal of the ivy permits viewing the decorative half-timbering and herring-bone bond brick in the front gable.

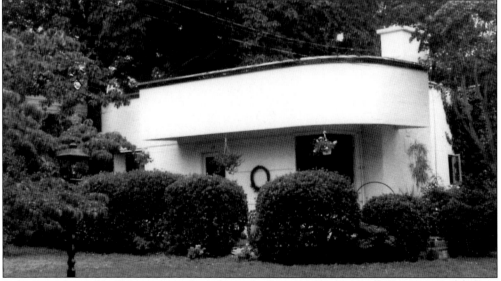

Robert O. Howard had this Art Moderne house built in 1936 at 17 Wardell Avenue by William Romaine of New York. Its architect is unknown, but its distinctive style, unusual in this region, has earned it listing on the Monmouth County Historic Sites Inventory. The Rumson Waterway is in the rear of the lot, a c. 1910 improvement of Ivins Creek, and a cooperative effort between the developers of Rumson Park on the east and Annie Millward, who owned the property on its west bank.

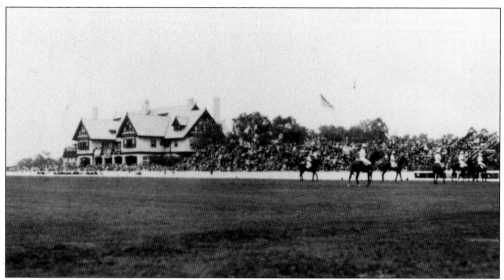

Polo, the sport that was the greatest outside draw in the early years and part of the festivities for the July 2, 1910 opening of the new Rumson Country Club clubhouse, is seen being played in front of a large audience in the 1920s. The Rumson Polo Club was one of three sporting groups combining to form the new organization. The Herbert Polo Field was named for the father of the United States game; the club once sponsored the Herbert Memorial Cup. (The Dorn's Collection.)

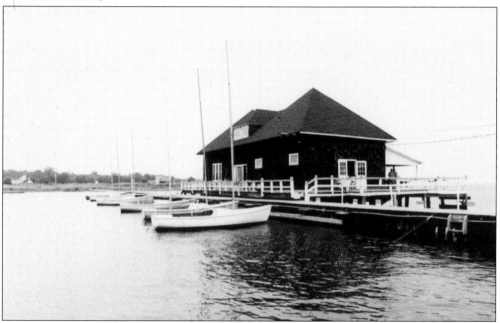

The Rumson Country Club's boathouse (seen here in 1981 and visible on the right in the picture opposite) probably originated with its Meadow Yacht Club forerunner. That organization built a clubhouse, designed by Harry C. Pelton, on the Shrewsbury River at Buena Vista Avenue in 1895. It may be the pictured building, a belief not confirmed by a contemporary account of a move. The boathouse was destroyed in the December 1992 storm with loss of much memorabilia.

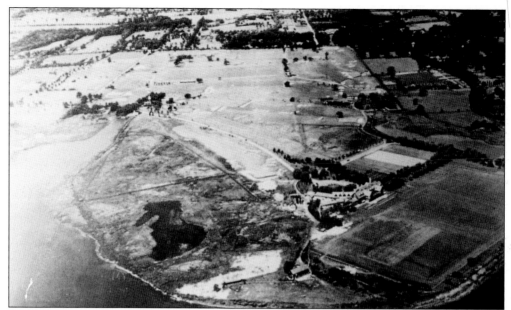

The Rumson Country Club was built in 1909, its grounds designed by landscape architect Charles W. Leavitt Jr. A large sum was expended on grading, dredging, bulkheading, and underdraining the grounds. Comparing this c. 1940 image with the 1954 image below highlights later work. Note the placement of the original clubhouse and the polo field (right foreground) and the pond (left). The view is looking north from the bank of the Shrewsbury River. (Collection of the Monmouth County Historical Association.)

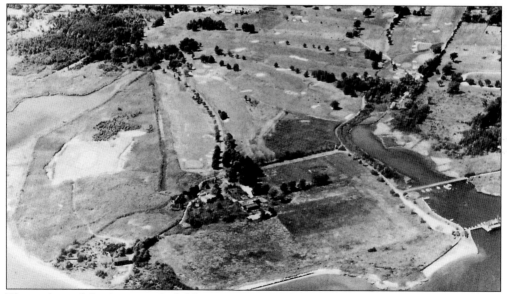

The outline of the former polo field is prominent in the foreground, while the new clubhouse is discernable in the background. The deteriorating condition of the bridge at right forced its closing and, as a result, the loss of a back exit to Buena Vista Avenue. Compare the light patch at left with the pond above. Shaping the land has been a long-time project. Twenty acres were filled in the winter of 1936–37, when the seventeenth and eighteenth holes of the golf course were built.

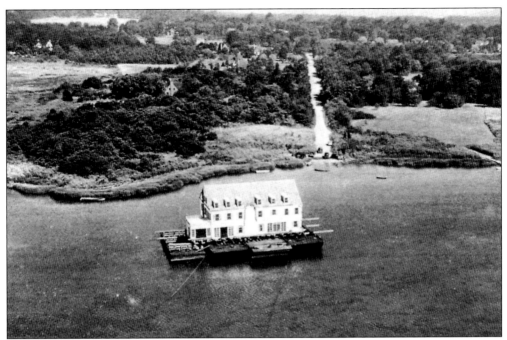

Edward W. Scudder bought The Point, the former William Everhard Strong place, in 1926 and sold the property for development in 1946. The moving of the house was described in *Rumson Vol. 1*, pp. 58–9. This is a close-up view of the house's move.

A closer view of the construction site suggests the how-to aspect of the land portion of the moving operation. It was not placed on the site of the original clubhouse, confusing many who study comparative views of club activities and facilities. (The Dorn's Collection.)

Two

Rumson Road

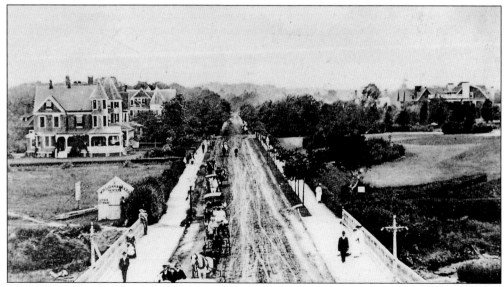

The view west along Rumson Road from the Sea Bright–Rumson Bridge was one of the town's most popular postcards c. 1905. The viewer can be confused by their frequent labeling as "Sea Bright," the common name then for eastern Rumson. The approach to the present bridge is J.C. Neeser's lawn at right. James Allgor purchased the lot at left in 1906, erecting a house that became subject of a dispute that inspired his many spite fences.

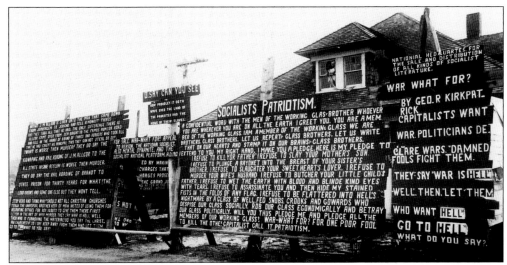

James M. Allgor's rancor with local authority stemmed from the denial of permits for an ice cream shop and bowling alley he wished to place in his home at One Rumson Road. Certain things just were not done on Rumson Road, the absence of zoning laws notwithstanding. He responded by erecting spite fences. Their crude, poorly spelled messages outlined his feelings and hinted at accusations of wrong-doing by his tormentors. Allgor was a socialist, but the local party was displeased by his invoking their cause. Note the flag, "O, Say can you see how proudley (sic) it doth wave over the land of the parasites and the home of their slaves." (Collection Red Bank Public Library.)

IT IS SAID THE RUMSON ROAD THEIVES ROBBERS
AND PARASITES DID SUGGEED IN OBTAINING PARDONS
FOR THERE THREE GOMRADES Mr. MORSE HEIKE AND
WALGH. BY PETITIONS TO PRESIDENT TAFT AND
THAT THEY WILL NOT BE GONTENTED UNTILL THE
HAVE PROGURED HOMES FOR THEM ON THE FAMOUS
RUMSON ROAD. BIRDS OF A FEATHER FLOGK MID
THEM SELVES. NOTIGE NO PETITION ON THE RUMSON ROAD
FOR POOR BRANDT WHO WAS RAIL ROADED TO STATE PRISON BY
MASTER FOR THIRTY YEARS FOR A GRIME THAT HE NEVER GOMMIT
WHO HAS DISGRAGED OUR FLAG? RUMSON ROAD. N. J.

This panel is the section at right in the image above. The allusions are vague; it appears the Rumson Road crowd spared Morse, Heike, and "Walch" in some manner, but the three were not Rumson Road residents themselves. Who was poor Brandt, anyway? Perhaps the substance of the complaints will be found in the press. Dating the pictures is difficult. Some have hints; most are *c*. 1909–13. (Collection of John Rhody.)

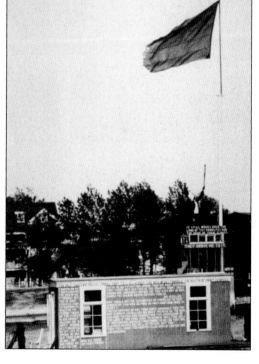

NOTICE J M ALLGOR IS LIKEN UNTO THE MAN THAT CAME DOWN FROM JERUSALEM TO JERICHO AND FELL AMONGST THIVES AND THEY TOOK ALL THAT HE HAD. THE ONLY DIFFERENCE THERE IS ALLGOR CAME OVER FROM SEA BRIGHT TO THE FAMUS RUMSON ROAD AND FELL IN THE HANDS OF A BAND OF THIVES AND ROBBERS WHO TOOK A THAT HE HAD EXCEPT HIS PRINCIPAL THIS THEY CAN NOT STEAL OR BUY.

?WHAT IS WORSE THEN MURDER? THEY DO SAY THE KIDNAPING AND RAIL.ROADING OF J.M.ALLGOR TO THE N.J. STATE INSANE ASYLUM IS WORSE THEN MURDER. THEY DO SAY THE RAIL ROADING OF BRANDT TO STATE PRISON FOR THIRTY YEARS. FOR WHAT?THE LORD KNOWS AND SOME ONE ELSE BUT THEY WONT TELL.

STOP READ. AND THINK. WHY? SHOULD NOT ALL CHRISTIAN CHURCHES TEACH THE UNIVERSAL BROTHER.HOOD OF MAN INSTED OF USING THEM FOR RECRUITING OFFICES FOR BOY SCOUTS TO GIVE THEM THERE FIRST LESSON IN THE ART OF WAR MURDER. THEY SAY WAR IS HELL. WELL THEN WHO IS FURNISHING THE MATERIAL? DO YOU SAY THE CHRIST. IAN CHURCHES? IF SO I SAY KEEP AWAY FROM THEM AND LET THEM GO TO H—WHAT DO YOU SAY?

Allgor was first sent to the insane asylum in 1912. Today he would probably be extensively covered by television (the media do worse, of course—at least he would have provided a break from the fires and shootings that currently dominate the news). He seemed to invite responses from passers-by, ending this panel with, "What do you say?" His location was the first house on the left as one crossed the Sea Bright-Rumson Bridge, so he attracted quite a few strollers. (Collection of John Rhody.)

Allgor took to a houseboat after being "silenced" on Rumson Road. His sign under the well-worn flag is "It still waves over the land of the parasites and the home of their slaves. They drove me to it." It is also a rare glimpse Allgor. The chronology of his messages can be inferred only occasionally; few postmarked examples of his cards are known. His death date and circumstances continue to elude the author. (Collection of Monmouth University.)

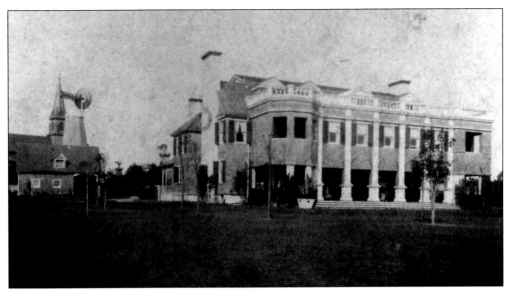

The Sidney Stratton-designed Colonial Revival house built at the northwest corner of Rumson Road and Ward Avenue for Samuel J. Harriot is seen *c.* 1910, perhaps at the time of a remodeling by a later owner, Bernon S. Prentice. The corner bay, porch, and front rooms appear to be additions. Holy Cross Church, visible in the background, purchased it *c.* 1940, remodeling it into a school. Harriot's carriage house (at left) is still part of the Holy Cross complex, minus its windmill, although the tower still stands. The house was demolished in 1963. (Moss Archives.)

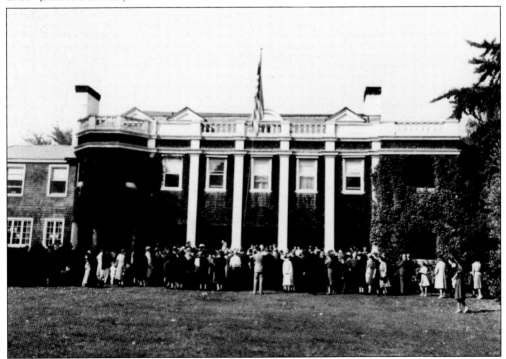

The Prentice home was bought in February and dedicated as Holy Cross School on September 27, 1941. This image appears to have been taken on that date. (The Dorn's Collection.)

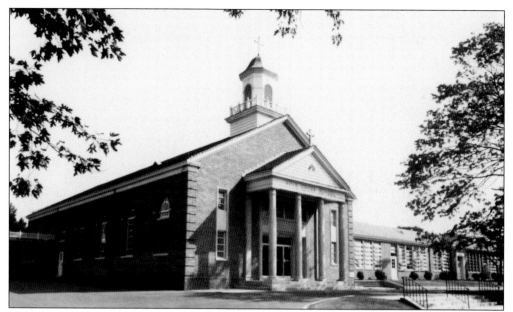

Holy Cross' growing post-World War II enrollment outgrew the original school. A new school was built in 1954 in the Colonial Revival style, designed by Frank J. Ricker and Louis A. Axt; the builder was S.J. Day Associates of Asbury Park. Six classrooms were added in 1962. Instruction was under the supervision of the Sisters of Mercy. This image is from 1956. (The Dorn's Collection.)

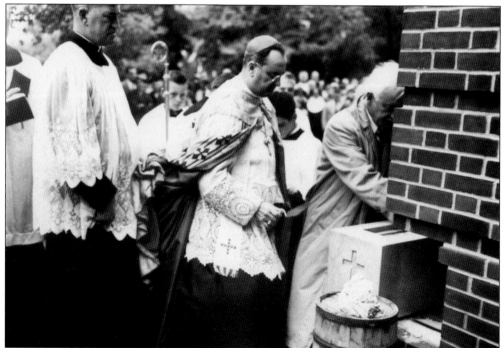

The not-yet-completed school was dedicated Sunday afternoon, September 23, 1954, and blessed by Bishop George W. Ahr (left), seen at the cornerstone-laying ceremony. (The Dorn's Collection.)

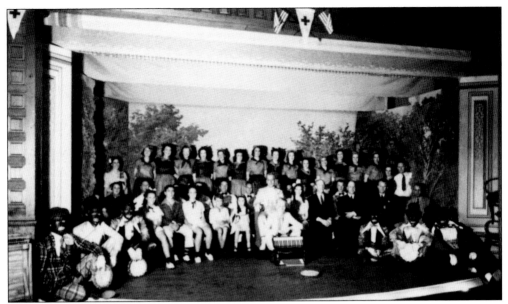

A Holy Cross minstrel cast, perhaps from the1950s, is viewed on stage. Sister Edwardine Brown recalled, "It was family-oriented entertainment involving the whole parish. We children sang or danced and practiced much of the year for an event staged at spring in the Holy Rosary basement or the parish hall at Holy Cross." Chris and Jack Deisler, who had charge of the production, were the end men. The minstrels, a long tradition there, ended some time in the 1950s. (The Dorn's Collection.)

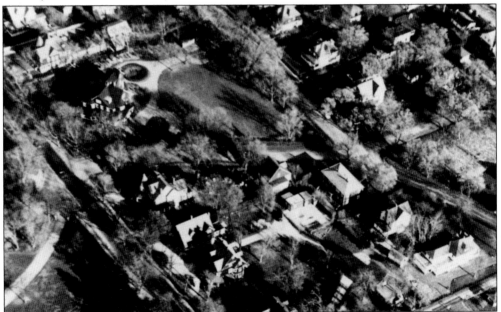

Rumson Road runs diagonally at left, from which Shrewsbury Drive begins its curved course running to the right. East of its start is the Ellen Kellogg house, likely built soon after her 1896 purchase of the lot. Two houses to its right is the house on the bottom of p. 33. Ward Avenue and the Holy Cross complex would be to the left if this late 1940s aerial had a wider view. (The Moss Archives.)

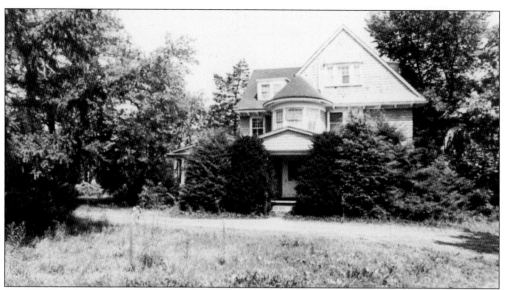

The Kellogg house at 21 Rumson Road was vacant and in a state of disrepair in 1984, but it was the subject of neighborhood preservation hopes. It was demolished and three houses were subsequently built on the site at the southeast corner of Rumson Road and Shrewsbury Drive.

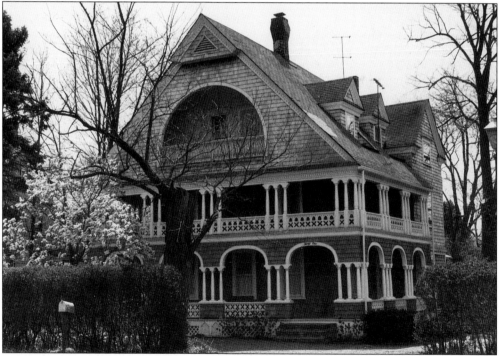

The open porches and gable balcony are the dominant features of the attractive Shingle Style house, unaccountably named "Queen Anne" and built c. 1900 at 31 Rumson Road. Details of its origin are lacking. Seen here in a recent image, the home was built by Charles Shropshire; a note in his wife's scrapbook indicates the plans were drawn by Mrs. Sarah Moy, a local resident, who one can infer gave artistic suggestion to the builder. The Minughs owned it by 1907, per the *Sanborn Atlas*.

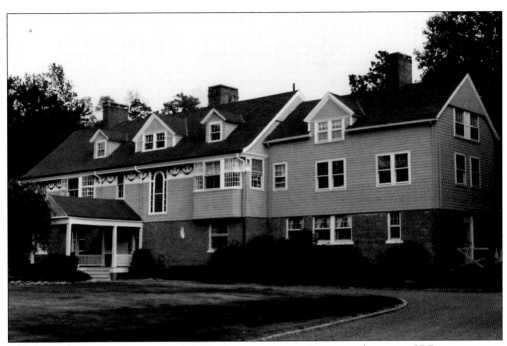

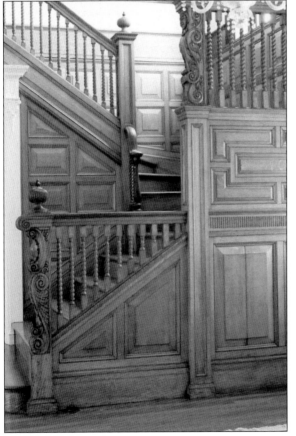

Ongoing change at 55 Rumson Road, seen in historic and comparative views on p. 28 of *Rumson Vol. I*, merits another look. A new painting, visible in the dark-on-light color contrast of the frieze relief, and the removal of paint from the bricks considerably enhance its eye appeal. Improvements are being made that respect the house's age and stature. Thomas and Elizabeth O'Mara fill the greatest needs of the historic property; they are young owners willing to make a commitment to preserve, restore, and care for it.

Richly carved staircases are often hallmarks of Bruce Price-designed houses. Those at 55 Rumson Road are well-preserved.

George Sheehan, born 1918 in Brooklyn and educated at Manhattan College and the Long Island College of Medicine, served in the navy and was a Red Bank cardiologist. He ran a 4:19 mile in 1939, only 12 seconds off the American record, and became widely known as an elder philosopher of running. He wrote and lectured extensively, continuing running into his final years despite a lengthy bout with cancer, an illness he also wrote about in a moving, personal manner. Dr. Sheehan, a former owner of 55 Rumson Road, died in 1993. He is seen at a 1974 awards ceremony.

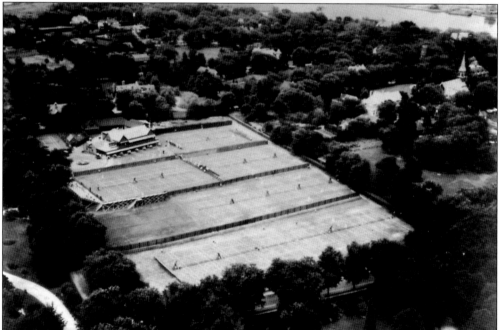

The Seabright Lawn Tennis and Cricket Club at Rumson Road and Tennis Court Lane is regarded as the second oldest surviving tennis club in America, tracing its origin to 1876. The first formal meeting was held in 1878, while the first club championships were held in 1879, won by William and Bessie Shippen. The club is famed for its grass courts, seen here in a mid-1920s aerial. The steeple at right is that of Holy Cross; the river is the Shrewsbury. (The Club's Collection.)

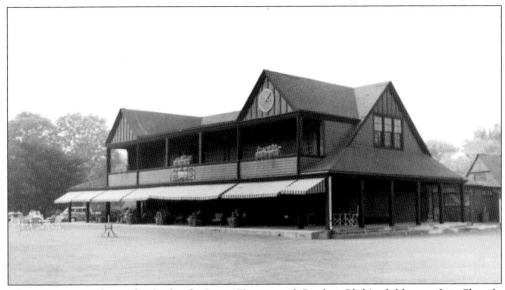

This 1963 image shows the Seabright Lawn Tennis and Cricket Club's clubhouse. It is Shingle Style with Tudor Revival elements. The clubhouse, built in 1886 to a design by Renwick, Aspinwall and Russell, shows a significant alteration on the south facade, the erection of a porch spanning its full length. Compare this view with p. 21 of *Rumson Vol. I*, and note the addition of a clock in the north gable. The clubhouse was designated a National Historic Landmark in 1992. (The Dorn's Collection.)

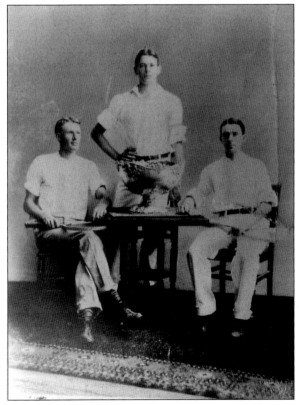

Malcolm D. Whitman (left), Dwight F. Davis (standing), and Holcombe Ward are seen perhaps *c.* 1900 around the time the former was winning club championships, including the 1899 Invitational and the 1900 Challenge Cup. Davis, among the most famed names in tennis for the championship cup he donated, won the 1899–1901 doubles championships with his Harvard teammate, Ward. He was a lawyer and secretary of war under Coolidge, from 1925 to 1929. (The Club's Collection.)

At left is Bernon Prentice with Holcombe Ward, *c.* 1920s. Prentice was a long-time president of the club, wrote its golden anniversary history in 1926, and won many singles championships from 1902 into the 1920s. Ward, a member of the first Davis Cup team in 1900, was the 1904 United States national amateur champion. He was long active with the Red Cross and served as president of the United States Lawn Tennis Association from 1937 to 1947. (The Club's Collection.)

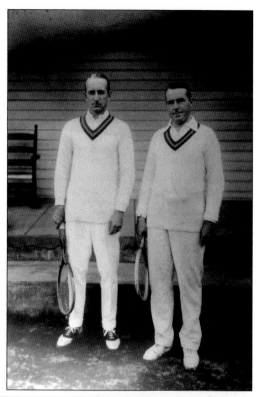

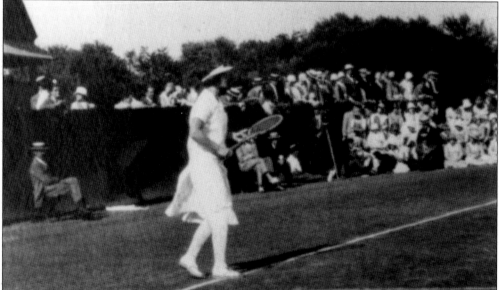

Helen Wills Moody, born in 1905 and one of the all-time tennis greats, played here in the 1930s. She was a 1928 Phi Beta Kappa fine arts graduate of the University of California. Moody won an Olympic gold medal in 1924, eight Wimbledon singles titles, and seven United States open championships. She was an effective promoter of women's tennis reform. Moody's presence at the club in this undated photograph is a reminder of its former prominence on the American tennis circuit. (The Club's Collection.)

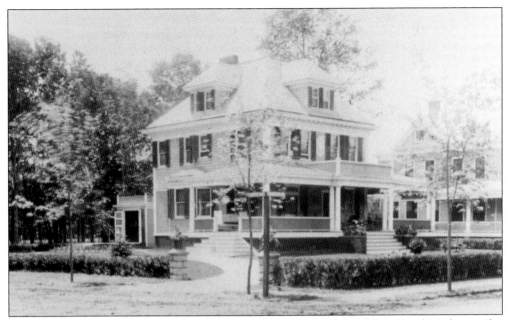

Ebenezer S. Nesbitt, a member of the Sea Bright hardware firm of Irwin and Nesbitt and a plumbing contractor, built in 1907–1908 this Four Square-style house at the southwest corner of Rumson Road and the then Forest Avenue. Designed by W.C. and A.F. Cottrell, the house's name, Woodmere (revealed in a crest in the facade), became the new name of Forest Avenue, likely *c*. 1919 when the Rumson and Oceanic Post Offices were consolidated. Only minor changes have been made to the well-preserved dwelling. They include removal of the front stairs, porch enclosures, and an expansion of the garage, in parts visible in this picture, and the addition of a rear room.

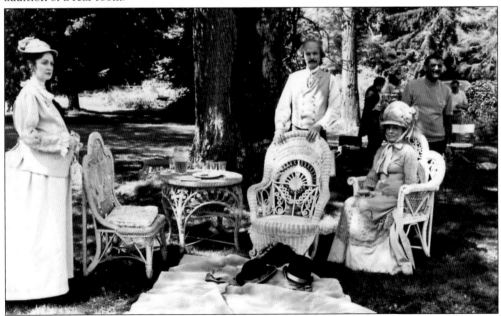

An episode of *The Adams Chronicles* was filmed at Rumson. Part of the cast and crew are seen at The Lindens, 141 Rumson Road, in August 1975.

This is a *c.* 1910 view of the entrance to Fairyleigh (as the 86 Rumson Road home of William A. Bloodgood was spelled in a usually reliable newspaper). Alternate spellings exist, including "Farrie Lee" on this card. Using secondary sources is unreliable, so one awaits finding Bloodgood's stationery for a definitive name. The house's origin is its 1879 section, designed by Edward H. Kendall for Thomas de Sotolongo. (Collection of Joseph Eid.)

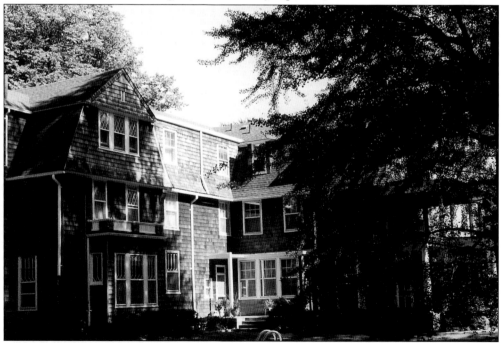

No old pictures of 86 Rumson Road are known. The southern facade seen on p. 33 of *Rumson Vol. I* is the large 1898 expansion, while this section on the northeast appears to be the original house. Note the lozenge-patterned windows, the second-story balcony, and the attractive gambrel on the roof of the gable.

The entrance to the Hermitage at the southwest corner of Rumson Road and the Avenue of Two Rivers is seen c. 1910. William A. Street's first land purchase was in 1882 from William E. Strong, with his home lot reaching about 21 acres. He hired McKim, Mead and White to design a large, Shingle Style house, built the next year.

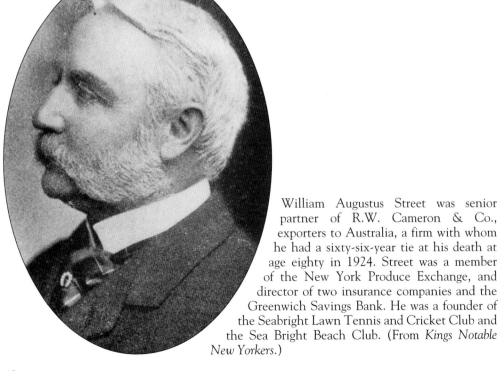

William Augustus Street was senior partner of R.W. Cameron & Co., exporters to Australia, a firm with whom he had a sixty-six-year tie at his death at age eighty in 1924. Street was a member of the New York Produce Exchange, and director of two insurance companies and the Greenwich Savings Bank. He was a founder of the Seabright Lawn Tennis and Cricket Club and the Sea Bright Beach Club. (From *Kings Notable New Yorkers*.)

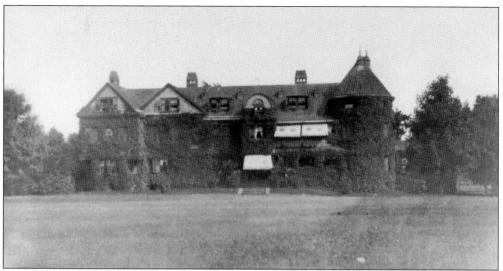

The Hermitage is McKim, Mead and White's only shore-area commission, with its integrity intact. This *c.* 1910 image, the first old photograph of the house discovered, reveals a little-changed north facade, with one visible difference: the four, window-sized dormers in the roof no longer exist. In addition, windows have been changed. Street's estate sold the place to Frederick H. Douglas in 1925. The house was threatened by deterioration, but was carefully restored by Joseph and Hollis Colquhoun in the 1980s. (Collection of John Rhody.)

The Hermitage's former driveways were closed, the house needed a garage, and it had an eastern approach that did not match the grandeur of the facade. George Rudolph, a New York and Red Bank architect, provided a solution with a garage resembling a gate house, styled to fit sympathetically with the house. An exterior staircase and open turret (not visible here) outside a second-story apartment make harmonious references to the house's open porches.

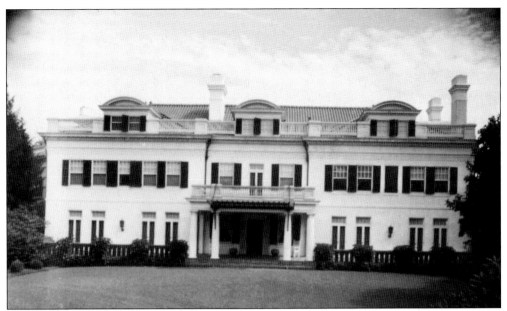

Lauriston, the tile and stucco house at 91 Rumson Road, can be seen in *Rumson Vol. I*, p. 38, from the air. Its style is Italian Renaissance Revival with Colonial Revival elements. This close-up view of the north facade, *c.* 1950, shows Leon Cubberley's design for Henry A. Caesar. The once-expansive front lawn has been reduced through the construction there of four houses. (The Dorn's Collection.)

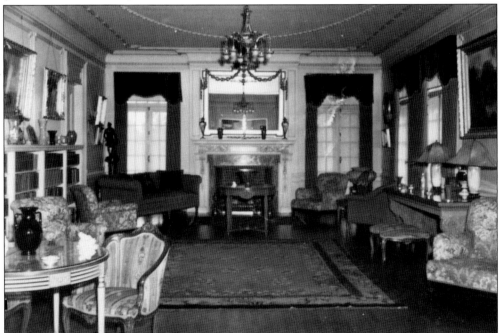

Lauriston was sold several times in the 1940s. The owner of the decor pictured may not be identified and the estimated date sometime in the 1940s may not be confirmable. However, the owner at the time of the image may be Caesar, judging from the trophies in this den. (The Dorn's Collection.)

Lauriston included an oak-paneled den. Caesar was a well-known sportsman and big-game hunter. (The Dorn's Collection.)

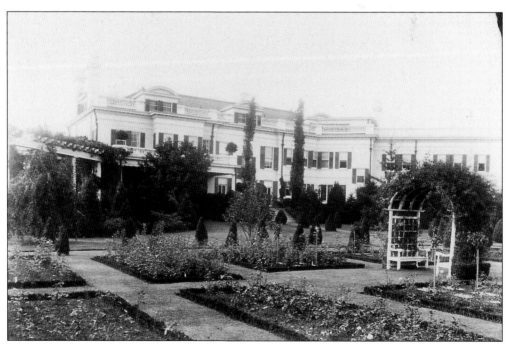

Laura F. Caesar was a skilled and well-known gardener. Her gardens were regularly published and exhibited on charitable house tours. This one is in the rear of the house. She died in 1942.

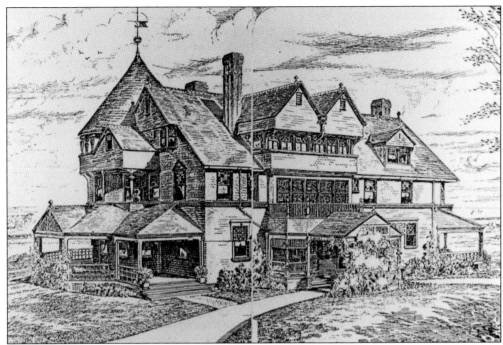

A pitfall of researching Rumson was the loose use of the term "Seabright" through at least 1910. Seacroft, the 1882 Brice Price-designed home built for George S. Scott, although built on Rumson Road as far west as Bellvue Avenue, was described in the January 6, 1883 *American Architect & Building News* as being in Seabright; it was listed under Sea Bright in the 1974 *Monmouth County Bibliography*. The north facade still bears some resemblance to this rendering from that issue.

Christopher D. Chandler, storekeeper, photographer, naturalist, and postmaster in Fair Haven, visited Terrell's grounds on February 12, 1909. He photographed this group of evergreens, apparently looking south toward the Shrewsbury River.

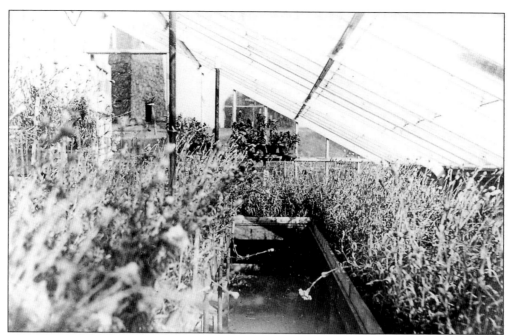

Chandler's interest in horticulture stemmed from a nursery business early in his career. This interior of Terrell's carnation house, a second image from February 12, 1909, is probably one of the structures on p. 45 of *Rumson Vol. 1*.

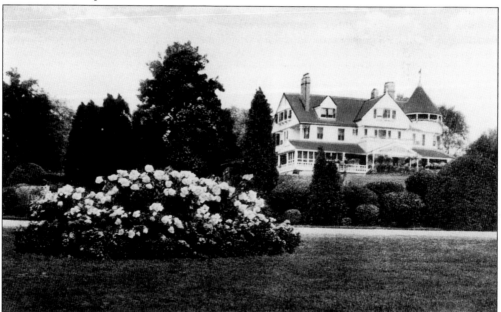

The Scott house was widely known through early-twentieth-century postcards, although it usually appears unidentified on them. It had been owned by Herbert Leslie Terrell, who bought an extensive tract and the house in 1892. This is the south elevation, extensively remodeled in the 1920s (architect unknown), with a Mount Vernon porch (*Rumson Vol. I*, p. 47). The Rumson Road address was removed following development, and the house is now approached via Allencrest Drive. (Collection of Michael Steinhorn.)

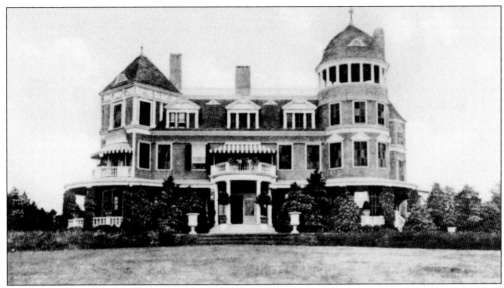

Sunset Hill was located on the north side of Rumson Road, east of Bellevue Avenue, and was apparently built by the Hutchinsons *c.* 1883. The place, sold to a Harding in 1909, no longer stands, the dates of its demolition and the construction of a new house not known. This image is *c.* 1910. (Collection of John Rhody.)

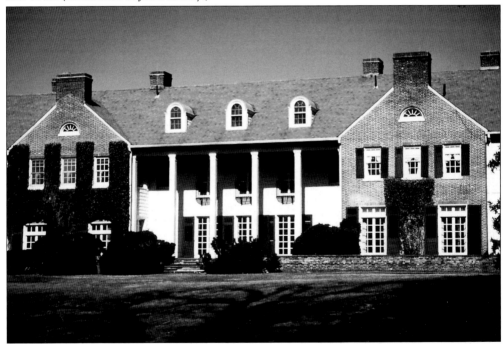

Manton B. Metcalf Jr. bought 26.5 acres at the northwest corner of Rumson Road and Bingham Avenue in 1925 from the widow of Andrew Bonner, and he apparently removed the old William Boardman house. In 1926, New York architects J.R. and F.B. Hinchman designed this substantial Georgian Revival house, completed *c.* 1928 at 142 Bingham Avenue. The house was enhanced by the grounds, one of Rumson's last, large undeveloped spaces, designed by Ellen Shipman. The Metcalf estate sold the property in 1996.

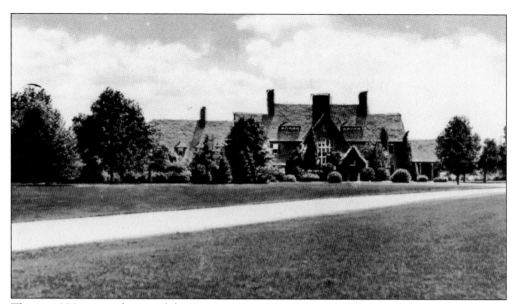

This *c.* 1930 postcard view of the Harrie T. Lindeberg-designed Thomas F. Vietor house at 99 Rumson Road shows the east wing; this is no longer present in the recent image in *Rumson Vol. I*, p. 36. The 1918 house was then owned by Henry E. Butler, who bought it in 1927 and sold it to Mrs. Harry I. Riker in 1934. The present appearance of Lloyd Christianson's home, who has owned it longer than any other, is little changed, except for the garage added on the east. (Collection of John Rhody.)

The east wing of the Thomas F. Vietor house was divided into two parts in 1952. Each was moved to a nearby lot on the west side of Bingham Avenue and expanded for occupancy as a separate residence. This section stands at 162 Bingham Avenue.

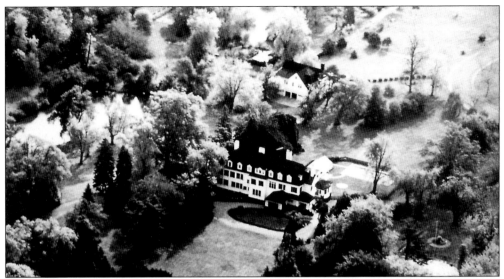

This 1950s aerial of 105 Rumson Road shows its *c.* 1915 remodeled north facade, but not the Queen Anne-style rear, part of the H. Hudson Holly design, left untouched in the remodeling of the front. The house, named Riverfields, retains an expansive front lawn and the rear carriage house. However, the southern part of the former road-to-river estate has been developed. Subtle, but significant, changes under the current ownership of Thomas and Susan Duff have given new luster to the well-preserved house.

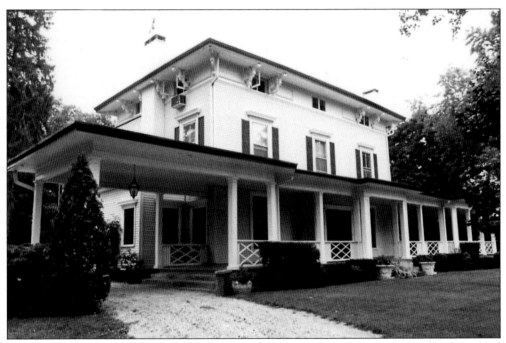

A second view (also see *Rumson Vol. I*, p. 40) from the northwest of the *c.* 1867 E. Gay Hamilton house at 108 Rumson Road shows porches and the porte-cochère, likely later additions. Expansions are away from the front view of the well-preserved, Italianate-style house, unique to Rumson Road, with the three-bay south facade likely reflecting the house's original footprint.

This *c.* 1945 aerial of Willowbrook, the 1931 Alfred Buselle-designed home of Hubert K. Dalton at 114 Rumson Road, indicates that the basic structure has not been extensively altered since his time. The style is basically Georgian Revival, although the house lacks true Georgian balance. The place, owned for a while by Mike Jacobs, was sold to Henry D. Mercer in 1947; it is still popularly known for that buyer, rather than the builder. A large expanse of its grounds south of Rumson Road have been dedicated to remain open.

The southern end of Fair Haven Road at Rumson Road is shown here on a *c.* 1915 postcard. This is a rare impression made from Christopher D. Chandler's glass plate, photographed on August 14, 1910. The Rumson Country Club is in the background.

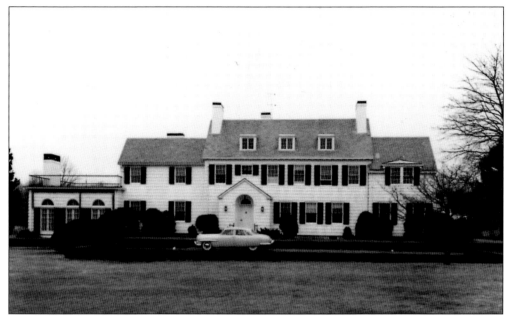

This is a 1951 photograph of the J. Ford Johnson 1930 remodeling (architect unknown) of the 1909 Thomas Tyndall Jr. house, which was built and designed by George Sewing at 178 Rumson Road. This view shows a greater expanse of the south facade of a well-preserved and little changed-since Colonial Revival than did *Rumson Vol. I*, p. 57. No picture is known from the Tyndall era, but the original house would likely reveal a farm structure quite different than the then-existing eastern end of Rumson Road, the present house, or the Rumson Road of Johnson's time. (The Dorn's Collection.)

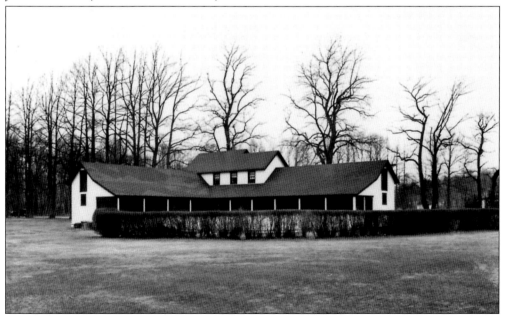

J. Ford Johnson was a noted polo player and a fixture at the Rumson Country Club. He stabled his polo horses on the premises; this barn structure, shown here in 1951, no longer stands. (The Dorn's Collection.)

Three

Rohallion

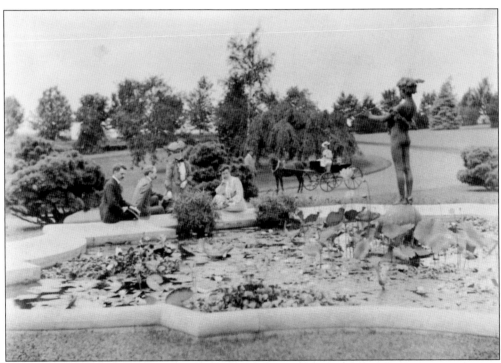

The Adams family is seated at their fountain containing the famed statue, *Pan of Rohallion*, sculpted by the youthful Frederick MacMonnies. Then a student of Augustus St. Gaudens, Pan helped widen MacMonnies' reputation, as he went on to a major sculpting career. The statue became well-known early on, through smaller-sized replicas.

Edward Dean Adams was born in Boston in 1846; one ancestor was Henry Adams, whose descendants included presidents John Adams and John Quincy Adams. He graduated from Norwich University, Vermont, in 1864, beginning his banking career several years later with Richardson Hill & Company, Boston. He was later president of Niagara Falls Power Company, overseeing the construction of a major generating station at the falls and the construction of an industrial village named Echota. Adams wrote a two-volume book on the harnessing of the Niagara. This image from the turn of the century is from *Kings Notable New Yorkers*.

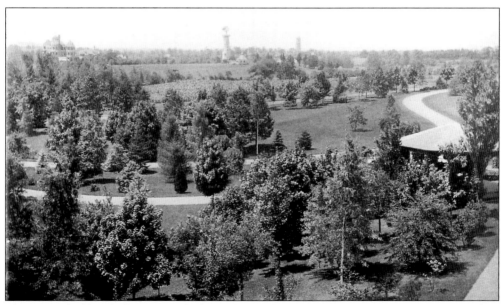

The grounds of Rohallion were laid out by Nathan F. Barrett, one of America's leading landscape architects, who enjoyed a fifty-year career. His early work included Central Railroad of New Jersey station grounds, but he soon specialized in laying out country estates. He also did widely recognized designs of new suburban and industrial towns. This view appears to be to the southeast, probably taken from the house.

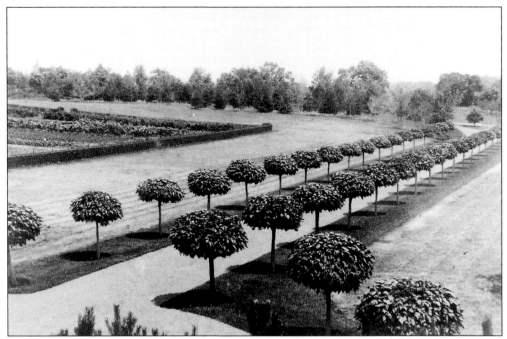

A row of catalpa trees lined the road leading east from the house to the stables. The catalpa is a native American tree with heart-shaped leaves, white flowers, and long, slender cylindrical pods. The rows are distinguished for the uniformity of the trees.

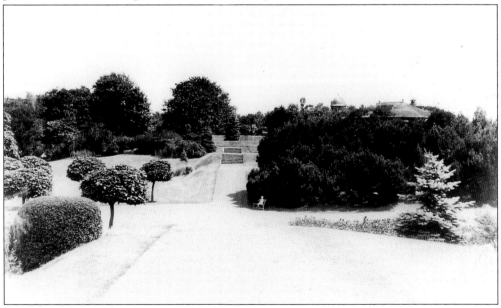

"Rohallion" appears to have a curious and amusing origin. One student of Scottish Gaelic, the previously attributed source of the name, indicated "Rohallion" does not translate in that language, but believes the name may come from Scots, an English dialect spoken in Scotland's Lowlands. The "Ro" is a street or ridge of ground, while "hallion" is a clumsy fellow, or a clown or scamp. Could Adams have engaged in self-effacing whimsy by calling his estate something along the lines of "The Scoundrel's Place?"

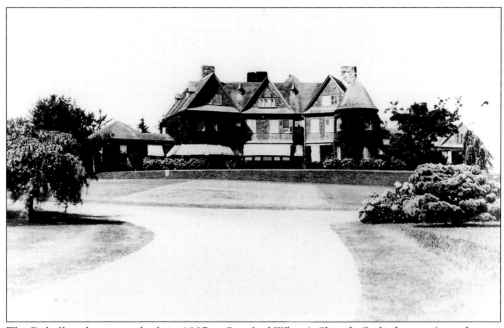

The Rohallion house was built in 1887 to Stanford White's Shingle Style design. As with most of his work, it likely involved a collaborative effort at his firm McKim, Mead and White. This photograph, c. early 1900s, probably reflects the original footprint of the house.

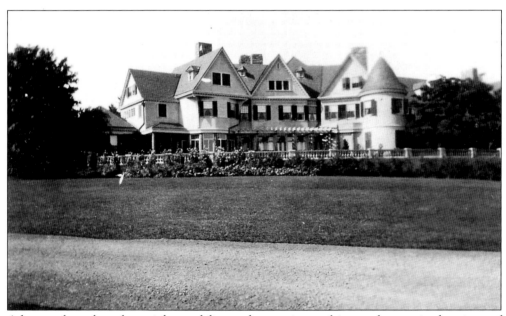

Adams undertook a substantial remodeling and expansion, architect unknown, in the winter of 1913–14. The contractor was Woolley and Burchell of Long Branch. A new tile roof was laid and the building stuccoed after the new wing was built. This image is from 1914.

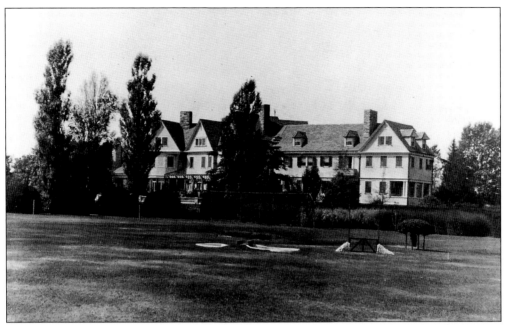

The wing on the east, measuring 23-by-80 feet according to a press account, is shown in a 1914 image.

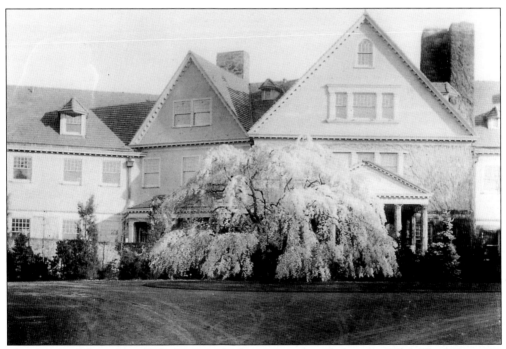

This image of the infrequently seen north elevation may include one of Rohallion's Japanese weeping cherry trees. The estate was sold to Robert V. White, a Rumson councilman, in 1929, who shortly thereafter began a Tudor Revival remodeling, giving the house its present appearance and effacing its earlier style. That era is not represented in this work, but a stylistic hint can be found on p. 66.

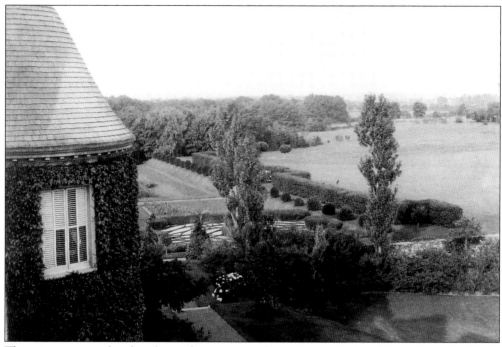

This view, apparently taken from a house tower, shows the proximity of the parterre garden to the residence.

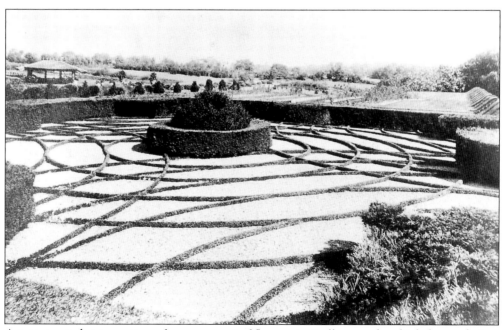

A parterre garden is a patterned arrangement of flowers, typically annuals, which form a design. The word is from Old French, "par terre," or "on the ground." The annual plantings made these gardens particularly labor-intensive.

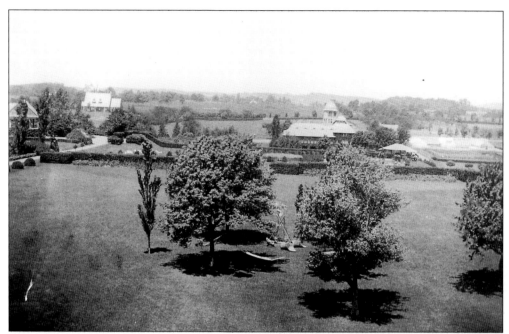

The carriage house/stable was located north and east of the house. A closer view is on p. 106 of *Rumson Vol. I*. Also designed in the Shingle Style by Stanford White, it contained a clock tower similar to his firm McKim, Mead and White's tower in the Newport (Rhode Island) Casino. Note the proximity of the greenhouses to the carriage house. The tower contained the Rohallion Chimes, cast for Adams with an unusual scale he worked out.

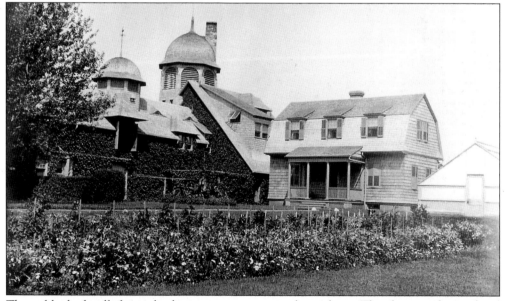

The stables had stalls for twelve horses; a garage section housed cars. The photograph is undated and it can not be ascertained if it was taken before or after an 1897 fire that caused major damage. The gardener's house was relocated a short distance to the east *c*. 1915. The carriage house was again extensively damaged by an April 1961 fire. A barely recognizable portion exists as part of the house at 8 North Rohallion Drive.

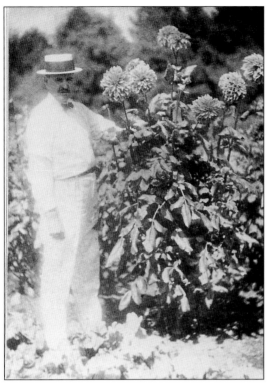

William H. Waite, a graduate of the Royal Botanic Garden, Edinburgh, Scotland, was superintendent of Rohallion. He specialized in dahlias, developing many new varieties, often naming them with the prefix "Jersey" to convey to the world the state's horticultural capabilities. He is shown here *c.* 1920 with one variety, Jersey's Beauty, in an image from his 1928 book *Modern Dahlia Culture*.

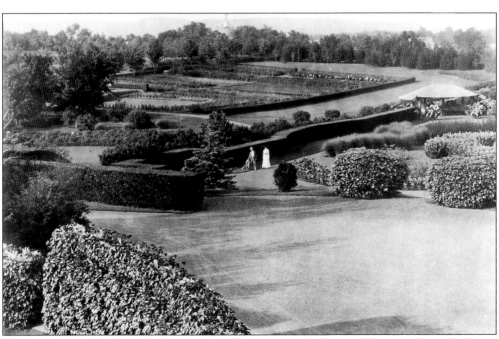

The grounds included over 3.5 miles of roads and paths, built of red shale to Barrett's design and color scheme. This view from the observatory suggests the extensive plantings of hundreds of varieties of specimen trees and shrubs. The Adamses often returned from travel abroad with plants for Rohallion.

The Adams family is seen, perhaps *c.* 1915, at the burial of Oji, a "highly educated" bird from Germany's Black Forest, beneath the Turkey oak planted by Ernest Kempton Adams. Oji was Ernest's companion for many years, including during his last year of illness. His repertoire "originally" contained six melodies (although it was not stated if it increased or diminished late in life).

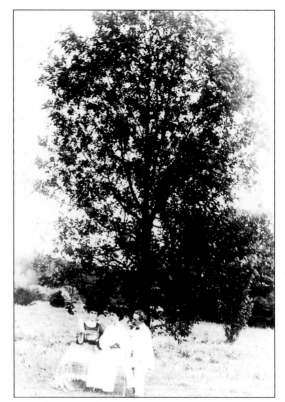

This image shows the removing of a large maple in 1916–17. The equipment and the size of the tree suggest the scope and difficulty of the project.

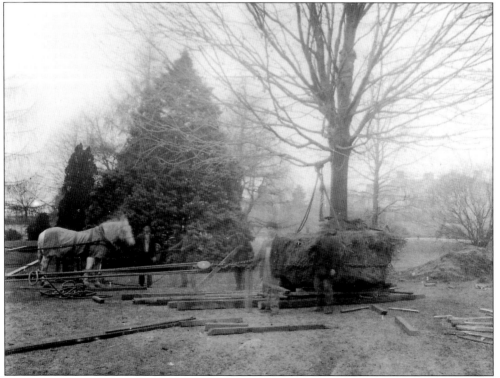

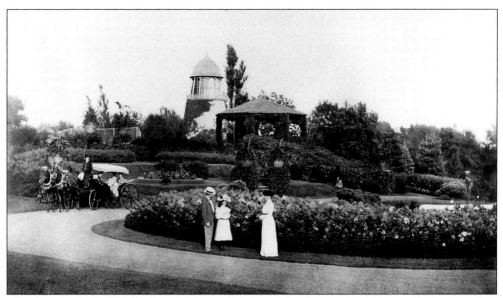

This 1902 photograph is helpful in establishing the location of the no-longer-standing observatory and gazebo in relationship to the extant pool, which is southwest of the house. The original of Pan was said to have found its way into a New York City bar. The story continues with the owner, wary of a questionable acquisition, having the statue placed in the Metropolitan Museum of Art, where it is now on permanent exhibition in the American sculpture court; a replica is mounted at Rohallion.

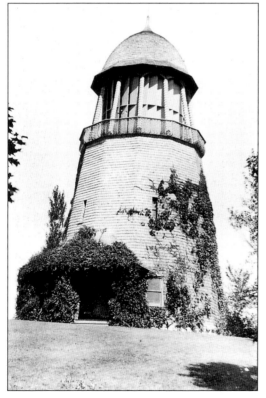

The water tower, containing the estate's pumping system, was located at the southern end of Adams' estate. An observation deck gave the Stanford White-designed structure the popular name of "the observatory." It was claimed the design of the no-longer-standing tower concealed its height.

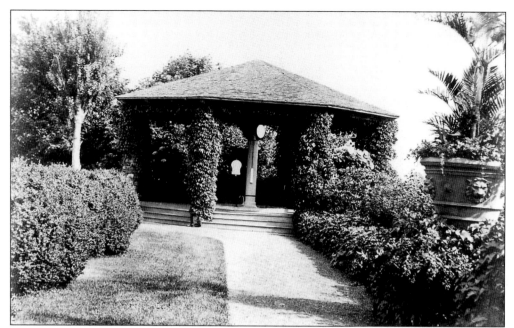

A gazebo was located northwest of the water tower.

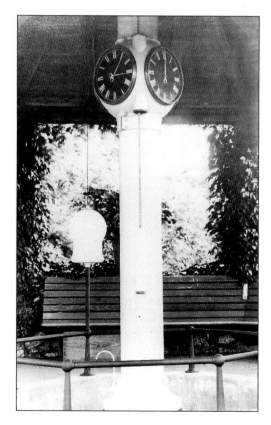

An impressive timepiece with four faces stood in the gazebo. Presumably, when working, the faces kept the same time. Note the rail at bottom, hindering the temptation of closer inspection.

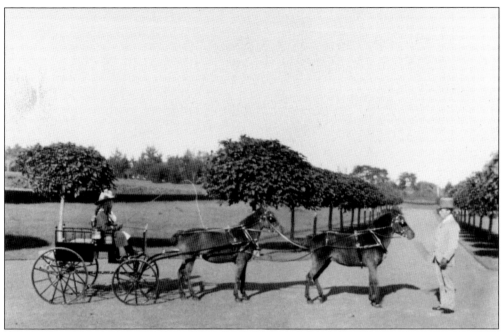

A carriage and two horses are at the end of Catalpa Avenue, as this path was known. The catalpas were cut down because of age-induced weakness and replaced by pink dogwoods of the same size in the fall of 1928.

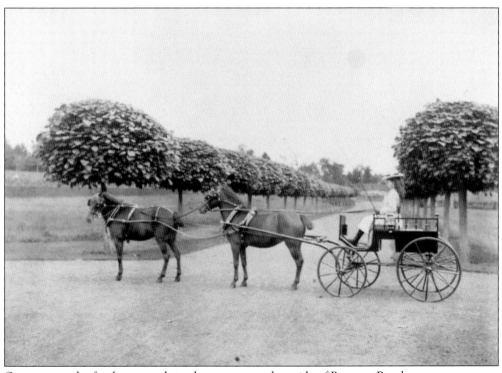

One expects the finely spanned steed were among the pride of Rumson Road.

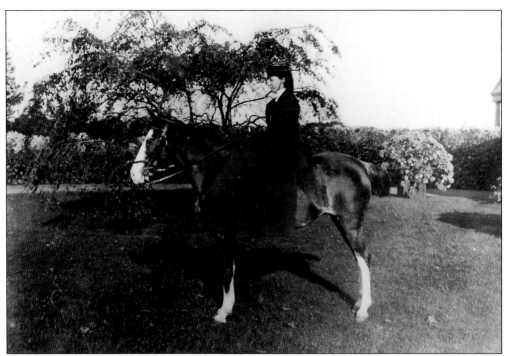

A smartly attired Mrs. Adams appears to have been an adept horsewoman.

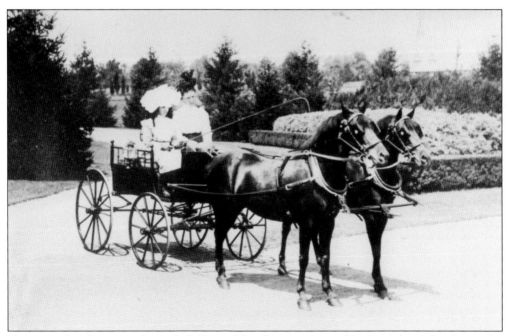

Horsemanship began early at Rohallion. The driver, presumably an Adams daughter, also learned to protect herself from the sun.

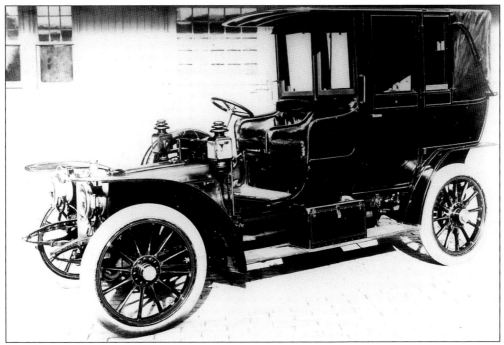

This is an unidentified family automobile. Edward Dean Adams was seriously injured in an automobile accident in Aiken, South Carolina, in 1931, never fully recovering from his condition.

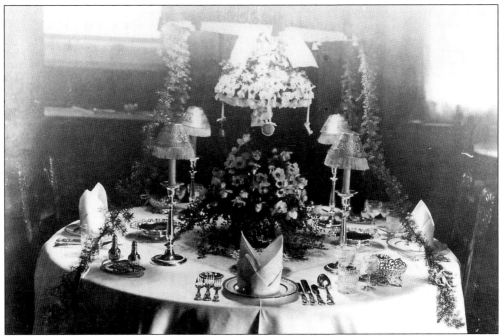

A set, small dining table is the only interior view present in an album that leaves the reader wondering about the possible location of other images showcasing Rohallion interiors.

Adams, shown here in a 1915 image was the director of the American Committee for Devastated France during World War I. His interest in literature, the sciences, and the arts resulted in numerous gifts to educational and cultural organizations. He was awarded a number of decorations from foreign governments, held numerous business positions, and was the member of many clubs. Adams died in May 1931 in New York.

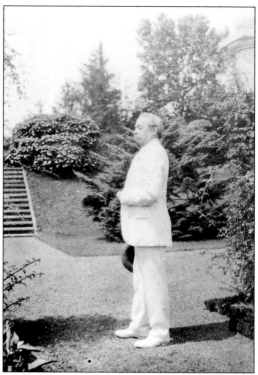

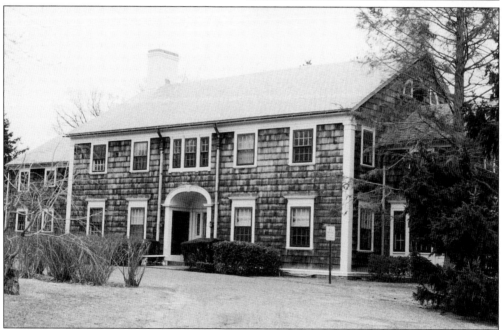

Edward Dean Adams built this Colonial Revival house on the Ridge Road border of his estate, at number 101, in 1927 in anticipation of selling Rohallion. Its architect is unknown. The house was built adjacent to the newly founded Rumson Country Day School and is now part of the school's facilities. Adams named the house Echota, the name of his industrial village near Niagara Falls.

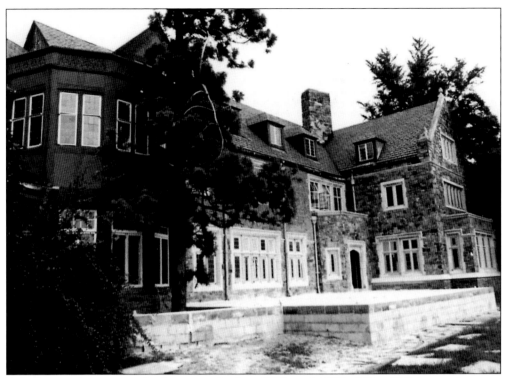

Rohallion underwent much change in the late 1970s and 1980s. This 1978 image shows an octagonal addition to the east wing. A garage was added to this end of the house. Note (at right) the character of the Robert V. White remodeling.

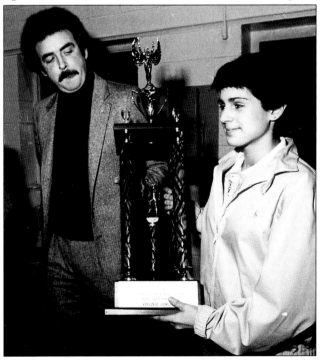

The Sourlis family owned Rohallion in recent years. Virginia Sourlis was a star basketball player at Rumson-Fair Haven Regional High School. She is seen receiving as a junior in 1981 the Kerwin Trophy, presented annually to the outstanding male and female players in Monmouth-Ocean Counties. Encore? She won it again in 1982 and went on to a fine career at Stanford. The presenter is John Kerwin, one of an active basketball family; the trophy is presented in the name of their parents, James J. and Margaret M. Kerwin.

Four

Oceanic and
East Oceanic

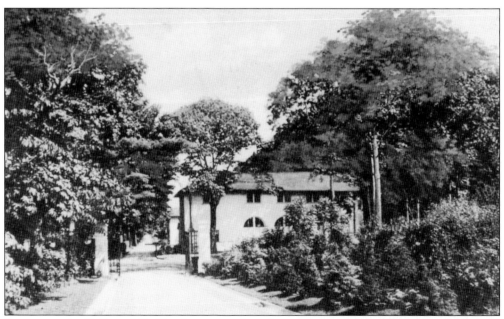

Popomora, the E. Drexel Godfrey house stood on the south side of River Road, overlooking an estate that ran to the waterfront. Although the house was demolished for development *c.* 1960, his important Italian Renaissance Revival-style garage, designed by Bosworth and Holden and built 1906–1907, is prominent near the road at number 90. Godfrey was a Hoagland in-law, selling Popomora in 1922, apparently moving to Auldwood (p. 118). This is a *c.* 1910 postcard view. (Collection of Michael Steinhorn.)

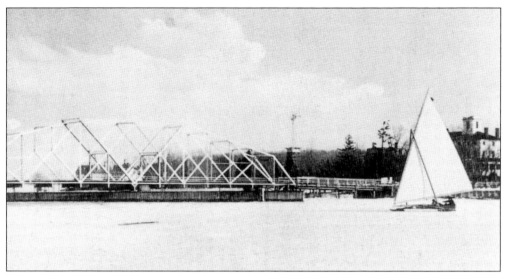

The 1891 Oceanic Bridge spanning the Navesink River to Middletown Township is usually seen looking toward the water. This c. 1910 postcard view, looking southeast from the steamship dock, is interesting as it shows the proximity of the draw to the Rumson shore. The Shrewsbury Inn, a hotel known by earlier and later names (p. 75) is in the background. The ice boat adds pictorial variety to a bridge more often photographed with a steamer. (Collection of John Rhody.)

Victory Park was built on Ligier and Brown property purchased by Bertram Borden in 1919 and dedicated July 4, 1920. The photograph of this ceremony was not identified, but it may be the December 19, 1947 conveyance of the park by the Mary Owen Borden Foundation to the borough of Rumson.

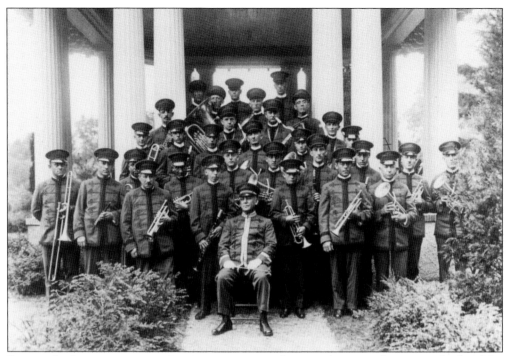

Rumson had a strong music education program in the years between the wars and a band for Victory Park, largely through the interest and support of the Borden family. This photograph of the band is not dated.

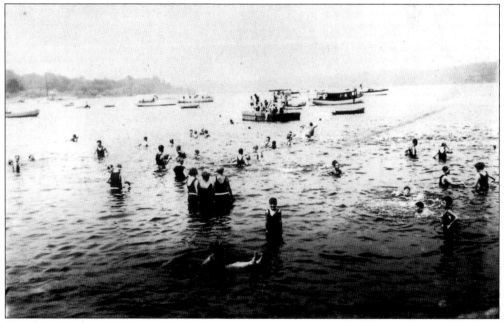

The Oceanic shore was a more active recreational site at the time of this image, c. 1920s, than at present.

Few changes have been made to this *c.* 1890s Zerr family residence at 22 2nd Street. An addition in the rear is hardly visible from this view toward the house's northeast corner. Otherwise, only the presence of siding and the absence of the fence differ. Even the porch balusters appear unchanged. Robert Zerr and Harold Zerr, father and uncle of the photograph's lender, Bob Zerr, are at left and right respectively. One suspects the middle figure is William, the third son of Jacob and Louise Zerr, but the identification is not certain.

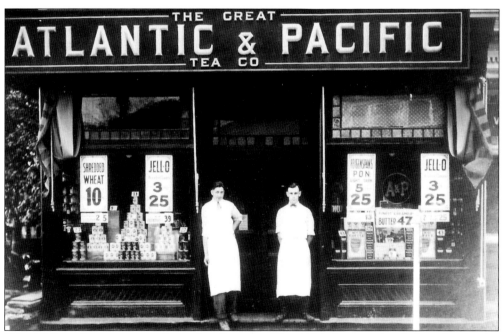

Two A&P markets were once located in Rumson. This 1924 photograph is believed to be the present site, but not building, at 15 West River Road. Frederick Moog Jr. is standing at left. Note that one could buy beer in a grocery then. Christian Feigenspan was a Rumson summer resident; his brewery's Pride of Newark beer was a New Jersey favorite.

Striker's general store, standing on the southwest corner of West River Road and Allen Street, was built in 1887 by William Pearsall and James P. Bruce. The trolley's single track included several passing "switches" or short double-track stems where a car could wait for one passing in the opposite direction; the Allen Street switch is shown above *c.* 1910. A gas station is now on the site.

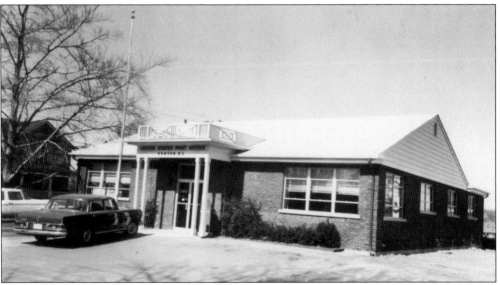

Post offices in Rumson were traditionally along the main (River) road. Separate Oceanic and Rumson offices combined in 1919. A need for parking led many suburban offices to relocate in the post-World War II era. The Rumson Hunt Street office opened in 1960, but was outgrown over the years. A new office designed by Stephen A. Raciti, built adjacent to this 1960 building, seen in a *c.* 1960s image, opened in November 1996. Only the facade of this one remains. (The Dorn's Collection.)

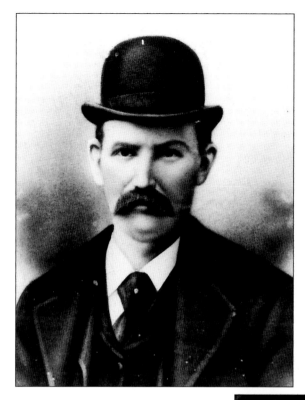

William Byrne, a greenhouse worker who immigrated to the U.S. from Ireland, resided on Washington Street with his wife, Anna. William, a Roman Catholic, died as a young man *c.* 1900, which occasioned Anna's return to Ireland. She was met with rejection by her family, having converted to her husband's faith.

Anna Byrne, born 1871 in Belfast, returned to Rumson to raise her three sons. She opened a small boarding house at 29 First Street, succeeding to larger ones, including the substantial Ohlandt Cottage at 18 Allen Street. Anna took winter jobs, including employment with the Bordens. Through thrift, she accumulated much Oceanic property, including the lot at First Street and River Road, which she donated to Holy Rosary Church, and her son's real estate office.

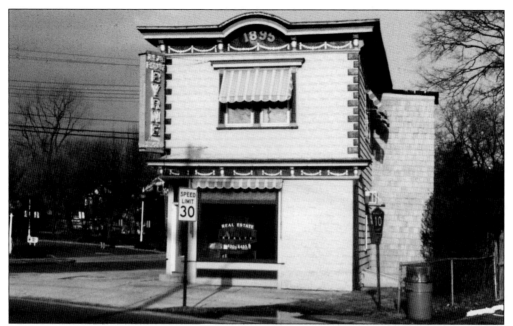

The 1895 Pearsall and Bogle store at 8 West River Road had a varied past, including spells as a gas station and soda fountain. Dennis Byrne began a real estate business in the 1930s, a response to a dearth of Depression-era jobs. Early activity focused on summer rentals, particularly to Hudson County residents. He maintained a local trade throughout his career, which ended in the late 1980s, rather than estate dealings. His mother, Anna Byrne, bought this building in 1944 (seen in a 1992 image), before it underwent a few color and name changes.

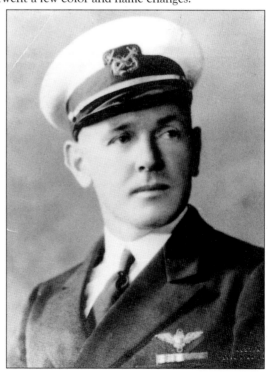

Patrick J. Byrne (born 1895) began flying in 1915 for Howard S. Borden. He enlisted in the navy in 1917, beginning his legendary career as a naval aviator in 1919. He flew over one hundred types of aircraft, amassing more flight time than any naval aviator in his day. Pat's specialty was the seaplane, a craft he was known to land on the Navesink. He was involved in establishing nearly every U.S. Navy seaplane base. His honors were numerous, but Pat Byrne would probably like to be remembered as a humble man and devout Christian. He retired as a lieutenant commander in 1958 and died in 1979.

The Navesink River shore east of First Street has a long history as a boat yard, known as Pullen's for much of the first two-thirds of this century. The Oceanic Bridge is at right in this 1960 image. (The Dorn's Collection.)

A 1960 land-side view of Pullen's shows boat storage facilities. A restaurant is on the site now. (The Dorn's Collection.)

The Rumson Inn restaurant, on the west side of Bingham, the first building nearest the Oceanic Bridge, was earlier an annex to the hotel pictured below. This photograph was taken in 1956, when the owner was Jack Madden. He operated the bar in the 1940s, buying and renovating the entire establishment in 1946. (The Dorn's Collection.)

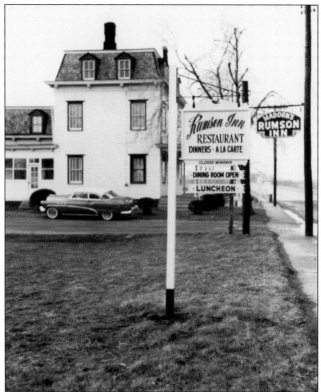

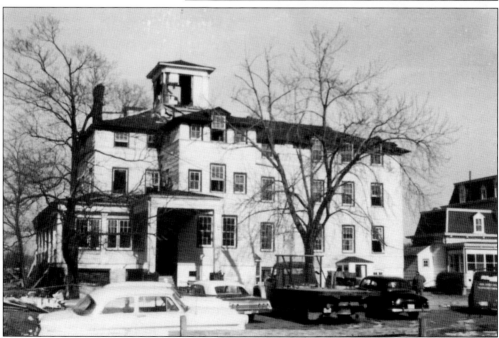

Hunt's Pavilion Hotel, later the Shrewsbury Inn and Rumson Inn (illustrated on the more-often-seen north facade in *Rumson Vol. 1*, pp. 78–9), is seen in its later days, *c.* 1963, on its south elevation. It appears to be in the early stages of demolition.

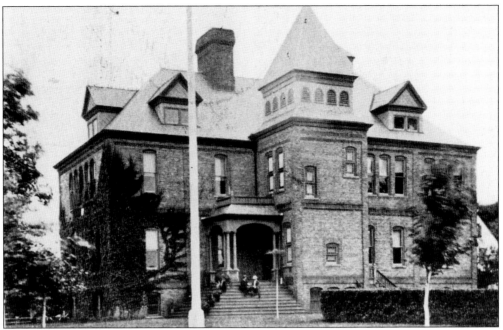

The Lafayette Street School at the northwest corner of Church and Lafayette Streets, seen in *Rumson Vol. I* from the street side, is viewed here from the interior of its lot. The 1893 "high school" went through the tenth grade, with students continuing elsewhere, typically in Red Bank. Borough tennis courts are on the site now. (Collection of Michael Steinhorn.)

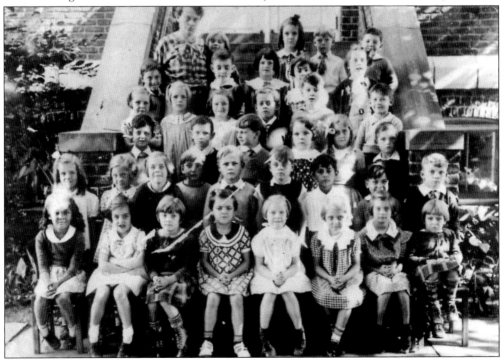

This is the first grade of the Lafayette Street School, *c.* 1935. Frank Trafford lent the picture, saying he is somewhere in there. Bobbi Carter Campbell is the girl on the left in the first row.

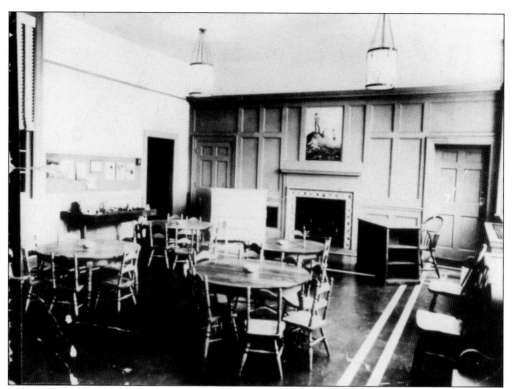

Sally O'Brien lent this rare, old but unidentified and undated image of a Rumson classroom. It appears to be an unusual setting for a class, heightening its mystery and interest.

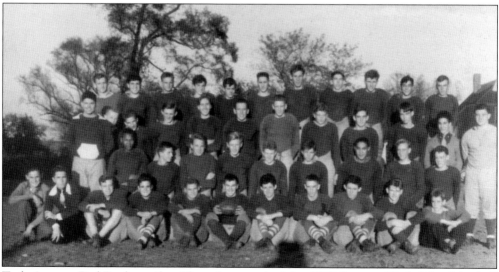

Tetley's was a Red Bank retailer. They photographed the 1937 Rumson High School football team to promote their equipment business.

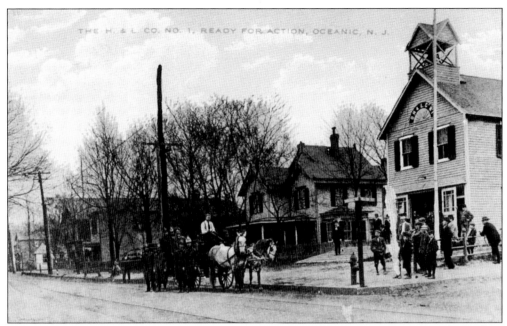

The Oceanic Hook & Ladder Company No. 1 was organized in 1879, meeting in the back of stores and offices. Their first firehouse, built in 1890 at the southeast corner of West River Road and Allen Street by local contractor William A. Jeffery, was designed by Whitney F. Williams. Note the long, wood ramp in this c. 1910 image. The house adjacent is standing, although it has been much remodeled.

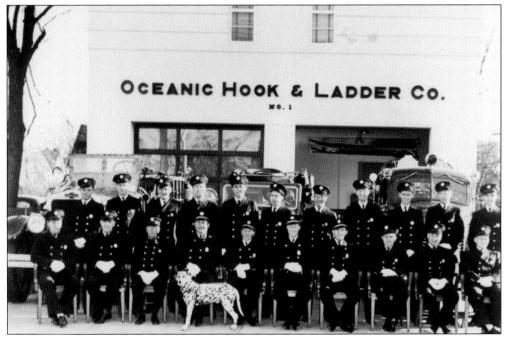

The Oceanic Hook & Ladder Company No. 1 posed for this annual photograph, c. 1947. Robert Zerr, father of the lender Robert (who shall be called Beezee to distinguish them), is in the rear at left. This building is the present 1939–40 structure (see *Rumson Vol. I*, p. 71).

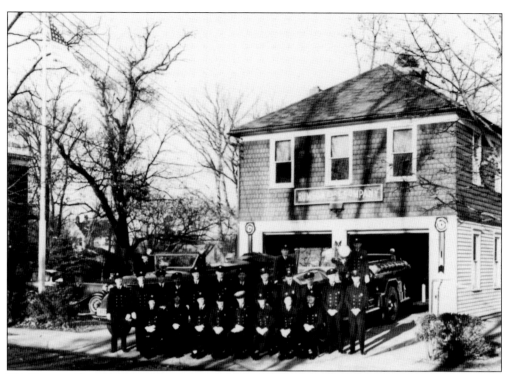

The Rumson Fire Company was organized in September 1905, and chartered the next year when they built this firehouse on Center Street, near Ridge Road. They occupied it until relocating to the southeast corner of East River and Black Point Roads. This building, with modifications, is now home of the Junior League of Monmouth County. The image is perhaps from the 1940s. (The Dorn's Collection.)

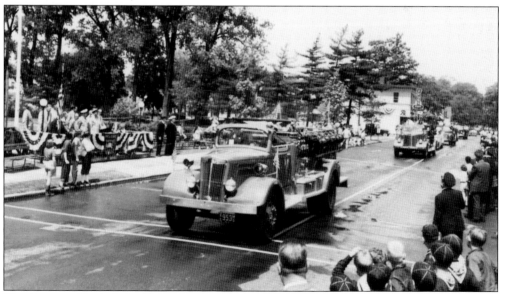

The Oceanic Hook & Ladder Company No. 1 celebrated its 75th anniversary with a parade on May 29, 1954. The procession is seen here moving west past a reviewing stand opposite the firehouse. (The Dorn's Collection.)

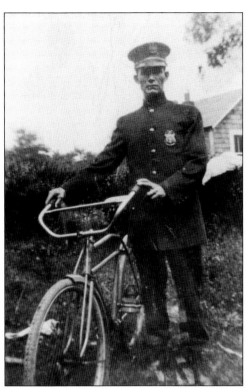

John McCloughlin was assigned badge #10 on joining the Rumson police force in 1918. His granddaughter, Sally O'Brien, claims he was their first motorcycle officer, but he is seen here in the1920s with a foot-propelled vehicle.

Bob Zerr, the lender, is not aware of the date of this photograph, but he believes the locale is the Rumson Country Club, and he knows his uncle Bill is sitting on the fender at left. Also in front, to Bill's left, is Jack Connett. Chief Henry Kruse has his hands on this knees. Mike Newhauser and Seth Johnson are in the rear. The third figure in front is John McCloughlin.

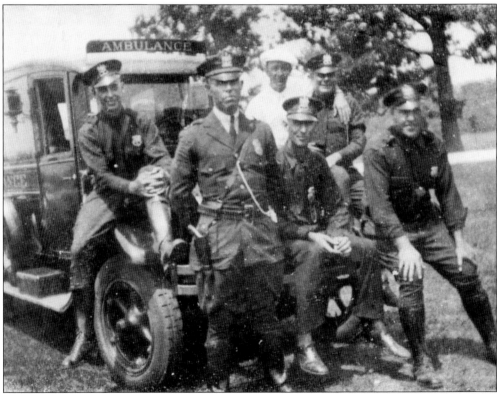

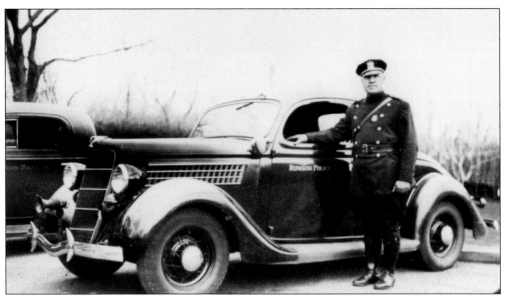

Henry Kruse, Rumson police chief, is seen with a Ford around 1936.

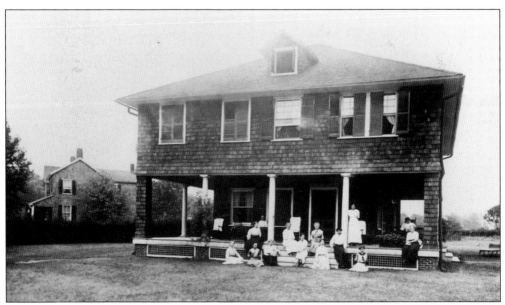

The Ellen cottage, operated in conjunction with the Armide Rest, was a summer vacation residence for New York City single, working women. Built c. 1900, it is seen in a c. 1910 image. Both buildings were on a large lot at the northwest corner of Black Point Road and the Avenue of Two Rivers. This one is now a private home at number 74 of the latter street. Porches, once surrounding three sides, are enclosed; this one facing the street is now a living room. The first floor has been much changed, but six former bedrooms on the second story suggest the character of the original occupancy. (Collection of Michael Steinhorn.)

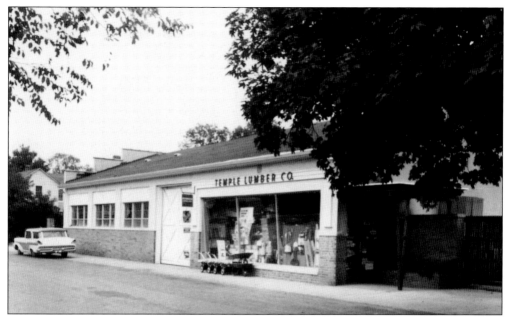

The Temple Lumber Company at 62 Carton Street, seen in 1963, reflects a time when smaller lumber/hardware businesses prospered in local, town-centered operations. Temple interests sold the operation to the Stender brothers, local builders. The place has seen various retail-food service operations in recent years, as lumber and hardware businesses gravitate to the highways. (The Dorn's Collection.)

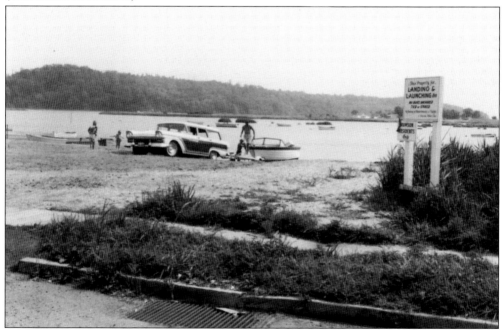

The Rumson municipal boat landing appeared in 1960 as little more than a clearing on a Navesink River inlet, behind the East River Road municipal complex. The Middletown shore is in the background. The present facility there includes a concrete ramp, a dock with a fishing pier, and a shelter. (The Dorn's Collection.)

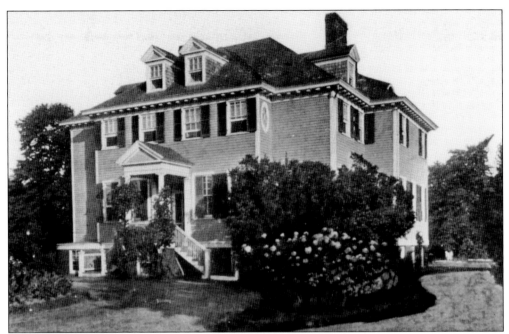

The Babies Hospital of the City of New York at 657 Lexington Avenue was incorporated in 1887 and maintained a summer branch in Oceanic, but documentary evidence of its time here is scant. This structure, formerly located at 65 East River Road, may have been the John L. Eccles house, which was sold in 1909 to an organization planning a babies hospital; however, the aforementioned branch was in operation by 1893. The hospital is believed to have ceased operation in the early 1930s. More evidence is needed about this c. 1910 image.

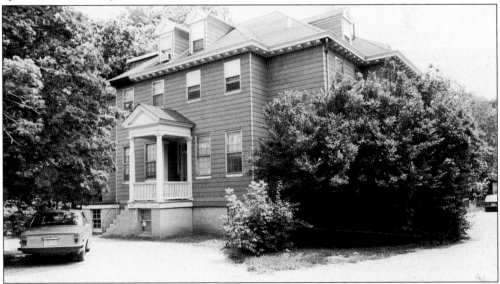

The former Babies Hospital, converted to apartment use c. 1940, is remembered fondly by many Rumsonians. As the only reasonable rental in town, it was a good first residence for newlyweds awaiting homeownership. It was demolished for the present condominiums at 65 East River Road c. 1980. How was it in its later years? One former resident recalled seeing "bugs we never knew existed."

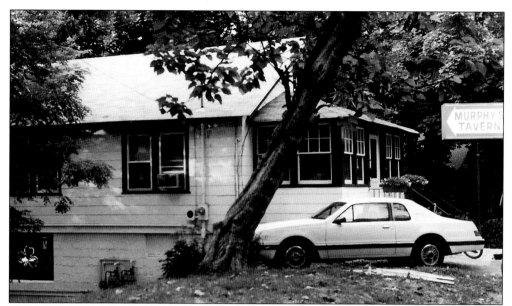

A bar on a Rumson residential street is not a typical find, but Murphy's Tavern has stood at 17 North Ward Lane since c. 1930. It has legendary origins as a Prohibition-era speakeasy, but today it is a quintessential neighborhood place, located in the basement with a residence above.

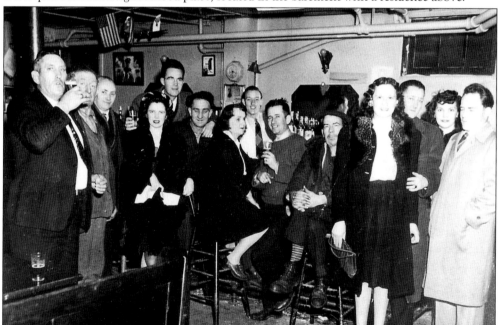

The c. 1940 merry-makers at Murphy's Tavern convey the establishment's present ambiance: a nice neighborhood place to have a drink. The interior is little changed and is seen looking toward the east wall. Mary Murphy, owner into the 1980s, is fourth from the right, seen with her husband, Francis, the founder. On the stool at center is Marie Brighton Hyrmiak, facing her husband, Steve. Dolly Smith is fourth from left, with her husband, Bill, behind her. Patty McGovern, at left, was well-known around town for his conviviality with a glass. (With thanks to Jane and Al Brighton.)

Five

The Bordens

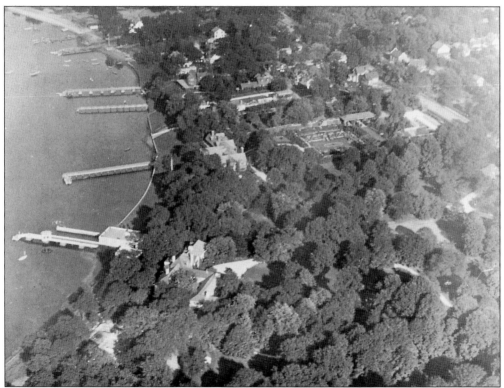

The Borden estate and a stem of Oceanic to its east are shown here in the 1920s. Matthew C.D. Borden, business associate Cornelius N. Bliss, the Rev. Thomas Hastings, and C. Foote established an enclave on the Navesink River in about the late 1870s, sharing a driveway. The Bordens, in time, bought the property surrounding Matthew's initial holdings. Howard S. Borden purchased the last of these pieces, Bliss' place, in 1914 following the latter's death in 1911.

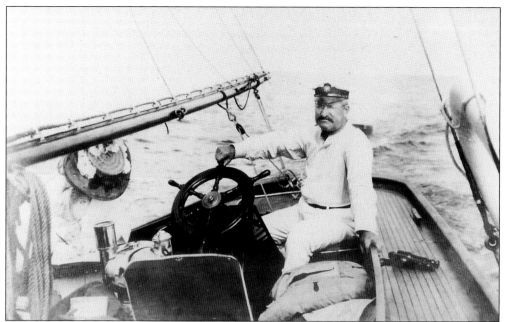

Matthew Chaloner Durfee Borden (1843–1912) was a legend in the fabric business and a noted sailor. Starting as a printer, he later manufactured his own cloth, giving him an independence that distinguished him from his competitors. He was willing to deter crises by bold moves. They included raising wages in a difficult 1899 labor strife and the purchase that year of enormous quantities of his competitors' fabric to save an overproduction-threatened market. A poor cotton crop that year brought him considerable profit.

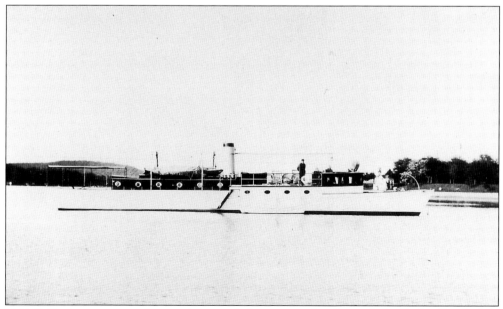

M.C.D. Borden was an ardent yachtsman, belonging to the Seawanhaka Yacht, South Side Sportsmen's, and Jekyll Island Clubs. His yacht, the *Sovereign*, seen *c.* 1900, was bought by the government and renamed the *Scorpion*.

The *Iris*, an impressive sailing vessel, demonstrated that Howard Borden, better known for his fast steam yacht, was a sporting sailor, too.

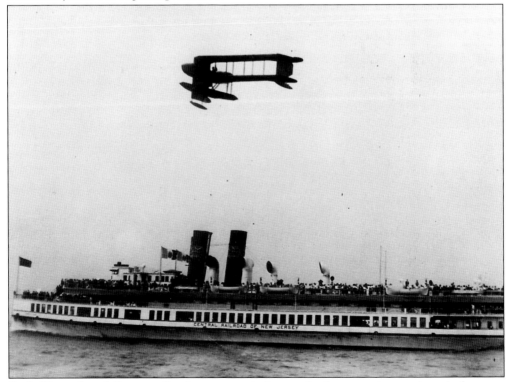

Both Howard and Bertram Borden were aviation enthusiasts, at times using airplanes to commute to New York. A Borden airplane is seen over the S.S. *Asbury Park*, c.1915.

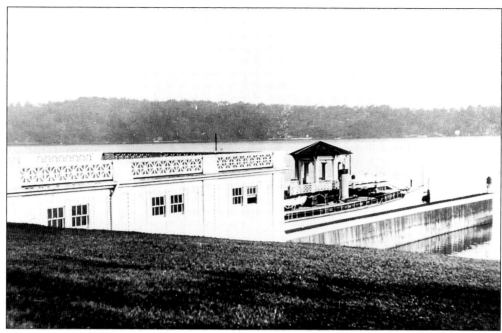

The *Sovereign* is at berth at the Borden boathouse, built in 1905. A major dredging job in 1911 had Matthews Bros. of Red Bank dig a channel 90 feet wide and 1,350 feet long from the boathouse to the main river channel.

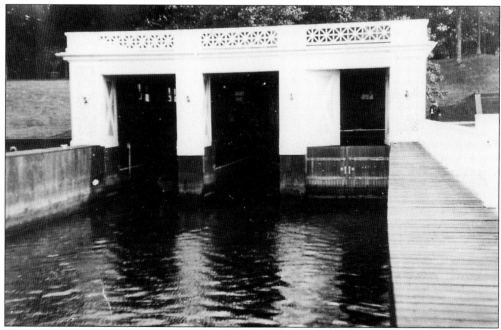

This mariner's perspective of the Borden boathouse was taken *c*. 1910, the date of both images on this page.

Borden's first carriage house/stable was built in 1889 near the street, now a residence at 85 West River Road (*Rumson Vol. I*, p. 85). Howard S. Borden acquired Cornelius Bliss' carriage house with the 1914 purchase of the latter's property. The main structure, pictured *c*. 1915, still stands; the one at right was replaced by a riding ring.

Bliss had a farm on the south side of River Road, but this view as one approaches north from the road appears to include a home garden. Borden's purchase of the Bliss property was prompted by a desire to preserve the western border of his own. He made good use of the carriage house, however, as evidenced in this sequence of photographs.

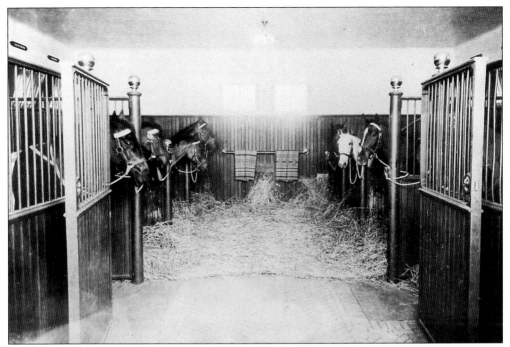

The Borden stables were well-equipped to house and care for their fine group of horses. This picture dates from 1917.

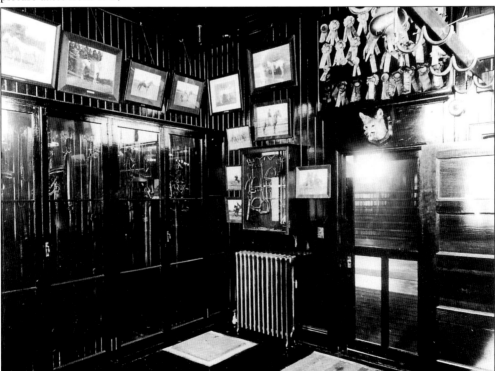

Photographs, awards, equipment, and yes, the reminder of a fox hunt, decorate the tack room of Howard S. Borden's carriage house, c. 1917.

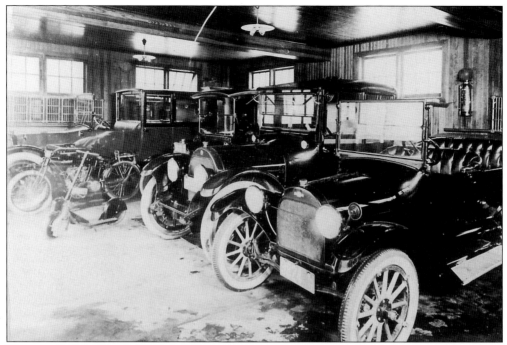

The car had replaced the horse as Borden's usual mode of transportation by the time of this 1917 image. The carriage house can be seen serving a dual function as both garage and carriage storage.

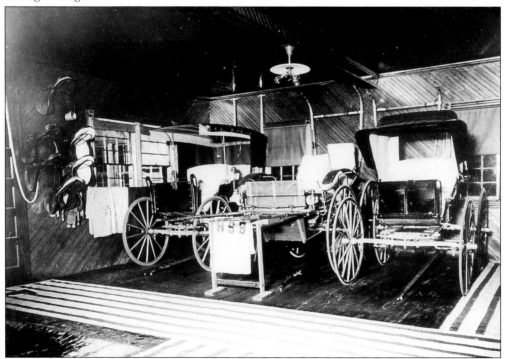

Many of Borden's carriages, some of which are shown here c. 1917, were stored in place until recent years, when the collection was sold.

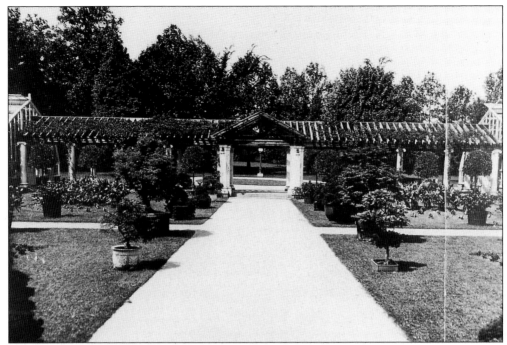

M.C.D. Borden built an elaborate network of greenhouses in 1901 at River Road and Third Street. The *Sea Bright Sentinel* of May 3 indicated they would be used for fruits and vegetables, in addition to flowers. The complex was built in the shape of a rectangle, open at the west side facing the estate's property. This image is of that opening, viewed from a path inside the enclosure.

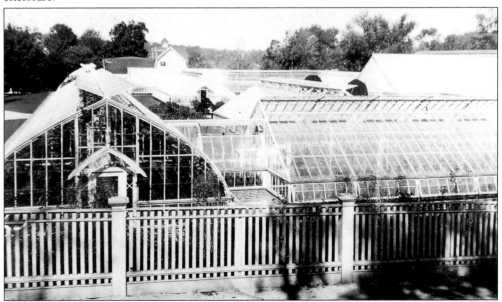

The short connection near the street of two long, perpendicular greenhouses suggest this view is looking north from River Road, an observation reinforced by knowledge that a two-story cottage stood north of the greenhouses. Borden had a two-story-with-attic farmhouse built in 1906, but identifying this as that one would be speculative.

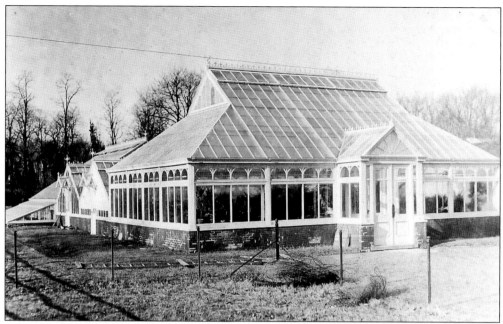

Orchids were among the Borden flowers, a planting revealed by a 1913 news account of their being destroyed by escaping gas causing reported damage of nearly $10,000. Most of the greenhouses have been removed. A private residence incorporates a section of their structure. The three photographs are, perhaps, c. 1910.

This is a 1917 image of the Borden cow barn, located near the stables and removed many years ago. The Rumson Bordens should not be confused with the dairy Bordens.

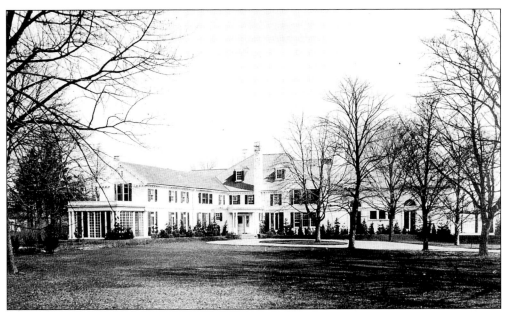

The origin of Old Oaks, the residence of Howard S. Borden, is unclear. Shown here c. 1915, it appears to have been built in several sections, with no known image of the original house available. Its study is hindered by extensive damage from a fire on April 27, 1926. The house was rebuilt around undamaged sections (*Rumson Vol. I*, p. 93), but parts of the reconstruction were removed in 1937 to build an additional house. The remainder of Old Oaks was demolished in 1996, and a new house was built there by an owner outside the family.

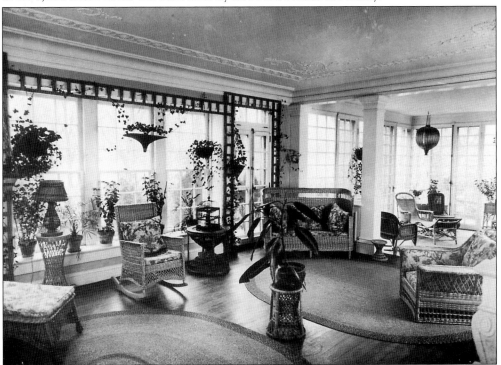

This interior appears to be the sunroom at left in the photograph of Old Oaks above, c. 1920.

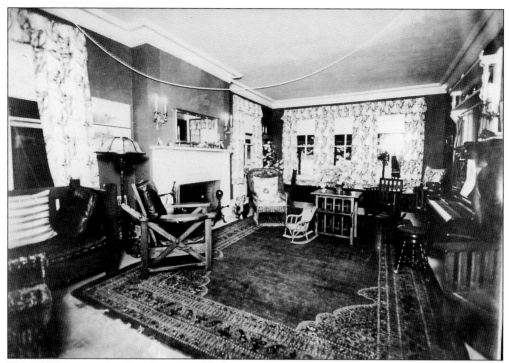

The ambiance, scale, furnishings, and lighting suggest this as one of the older, replaced houses on the Borden estate. This image is *c.* 1910.

The Borden property, and several lots adjoining on the west, are on a stem that runs about 1,000 feet from West River Road to the Navesink River. This early-twentieth-century view overlooks the Middletown Navesink River Road shore near the Oceanic Bridge.

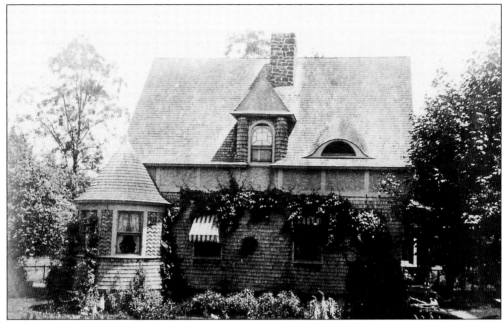

M.C.D. Borden built a gardener's cottage in 1901, designed by Carrere and Hastings. This building, although unidentified, bears artistic and stylistic similarity to the work Thomas Hastings did for Borden, including the design of the First Presbyterian Church. The building no longer stands and the author cannot make an assumption based on one photograph; however, this image may provide a missing clue for a historical piecing together of the Borden estate.

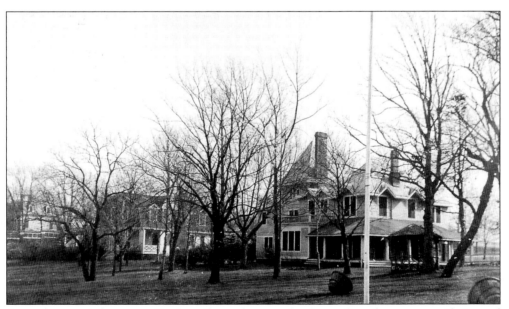

An early-twentieth-century Borden-album photograph of waterfront houses may, if pictured elsewhere with known landmarks, provide evidence of former buildings on their estate and establish that this image actually is Rumson.

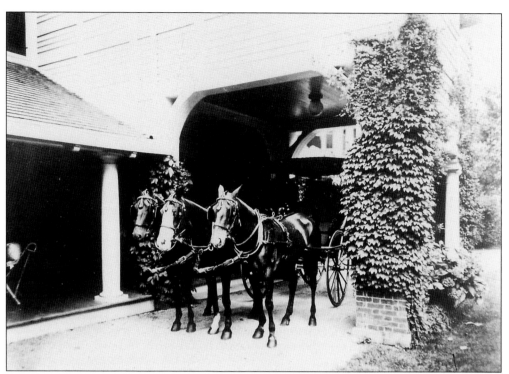

Handling a three-horse team took considerable equestrian skill. This group is seen *c.* 1915; later, most Borden horses were kept for polo.

Bertram Borden, through a lack of available material, is regrettably mentioned in this work only by this 1983 image of his house, built in 1920 at the eastern end of the family compound at 66A West River Road. Outstanding design and substantial construction make this one of Rumson's finest twentieth-century houses.

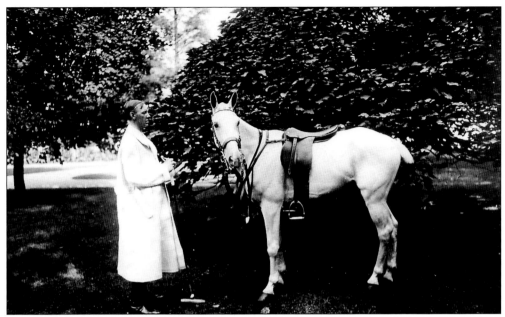

Howard S. Borden, seen here in the early 1900s, was a long-time polo enthusiast, playing long into his life. Van Halsey enjoyed telling the story of Borden's Old Oaks team that won the 1930 Rumson Country Club championship; the story is quoted in the club's 1983 history. Some younger players on the club team, not having won its own tournament in the 1920s, began complaining that Borden, born in 1876, may have become, per Halsey, "too old to continue arduous competition of that sort . . .

. . . Borden quit the Club team, founding his own, the Old Oaks, consisting, in addition to himself, of his son Arthur, Michael Phipps, Phillip Inglehart, and Raymond Guest. They 'easily defeated' the Rumson team, 'with Howard Borden making several goals, much to the discomfort of some of the players who thought he was a little antique.' "

If John Borden seems to have been destined to attend Yale, he was, as his father, Howard, was an enthusiast for his alma mater.

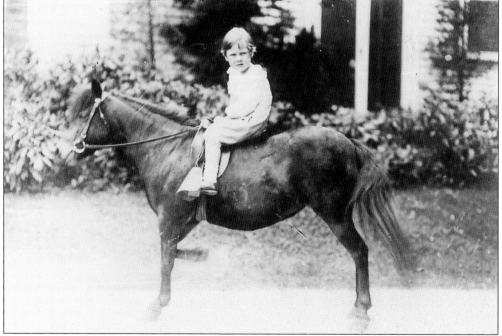

William Borden and his brother Arthur broke the Yale tradition their father was building by attending Princeton. The youthful William, seen sitting on a horse c. 1920, suggests early Borden equestrian training.

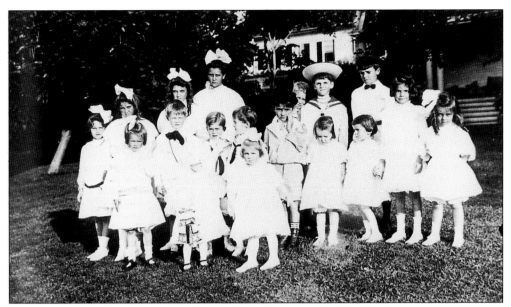

What the children lack in organized pose, they make up in their interest as an appealing group in party dress around 1915.

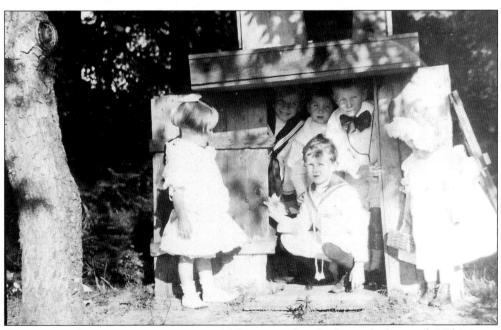

Does one get the impression no more would fit, or was the play house for boys only? This in an unidentified place at Borden's, c. 1915.

Six

Around Town

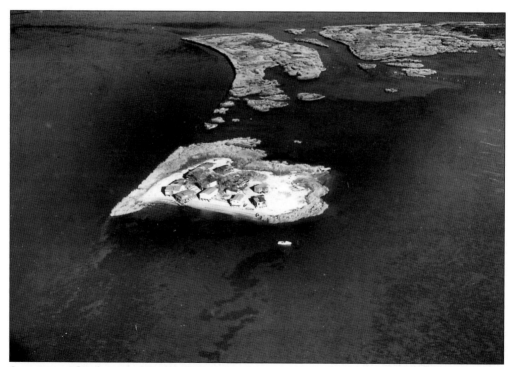

Starvation Island, east of Barley Point Island in the Navesink River, had a long tradition for summertime "roughing it." There was no land connection to reach its several houses, but island residents found the end of Navesink Avenue a convenient parking place. The houses were destroyed c. 1970s in a suspicious fire. The vacant island is now owned by the borough of Rumson. (With thanks to J. Gary Sammon, borough administrator; The Dorn's Collection.)

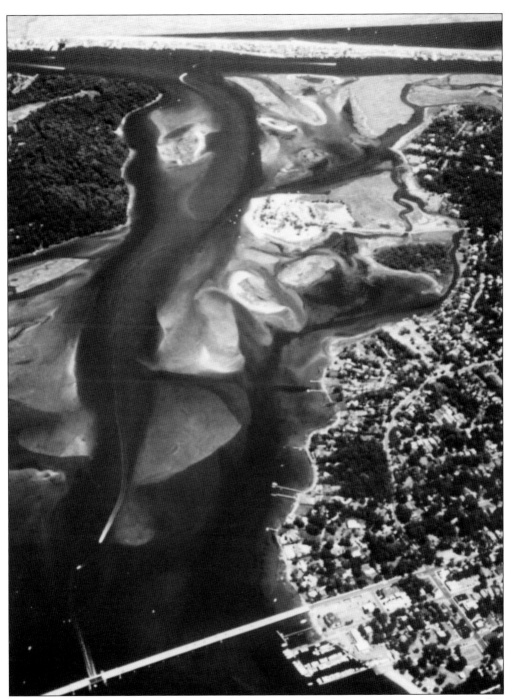

The Oceanic Bridge is at the bottom of this 1994 aerial, with Rumson at right, in a graphic image of the shoals that fill the Navesink River. Hardly visible on the surface, they almost appear ready to emerge as new islands (and maybe they will some day). The navigation channel is narrow; the picture makes it easy to see why. Barley Point Island is the one with the structures. Sea Bright is at top, and Middletown Township is at left. (The Dorn's Collection.)

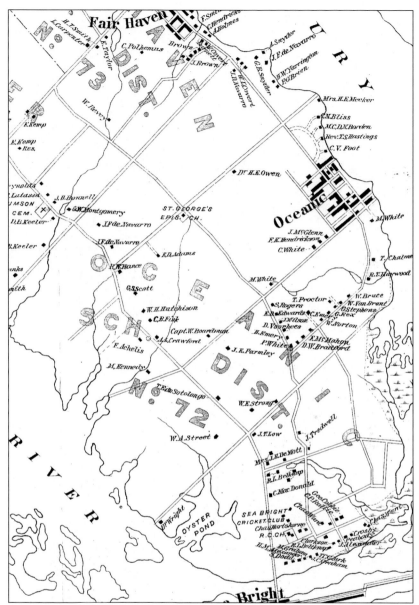

This map is part of Shrewsbury Township Plate 32 from the 1889 *Wolverson Atlas of Monmouth County*, tinted in light pastels to mark school district borders. Oceanic School District No. 52 was the first area proposed as the borough of Rumson. Its line started on Meekers Point on the river at top, proceeded south to Rumson Road (R.W. Hance), went west to Buena Vista Avenue, the next north-south street, then south to the river, omitting much of the Rumson established in 1907. Note the Borden estate at top, left of Oceanic village. Edward Kemp owned Rumson Hill, near the upper left corner. E.D. Adams, under St. George's (built on a corner of his estate), marks the location of Rohallion. Note the irregular shore of Oyster Bay (pond), then alternately called Wrights, for owner Wright to the west. There were only two country houses on the south side of Rumson Road, W.A. Street (p. 41) and Fritz Achelis (p. 48). Kennedy was a dairy farmer; most of this land was rough and unused, usually belonging to the tracts north of the road.

When Rumson Road was the Shrewsbury–Black Point Road, it connected that ancient village with eastern Rumson Neck's principal dock. The road veered north at today's Navesink Avenue. The spot on this *c.* 1908 postcard labeled "Black Point Road" is not identified, but it conveys the feeling of the old path. (Collection of Michael Steinhorn.)

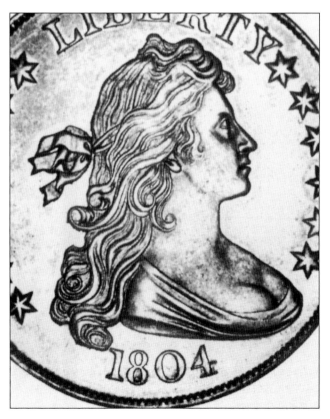

Anne W. Bingham, wife of William of Bingham Hill, was the model for the Miss Liberty stamped on early American coins. She was a friend of Gilbert Stuart and persuaded George Washington to sit for a portrait by Stuart, who eventually painted him often. Stuart chose Anne as model when solicited by a director of the mint for sketches for a Miss Liberty. His design was used on several denominations, beginning with the 1795 silver dollar. Known as the "draped bust" coin design, with reference to Anne Bingham's low-cut, flowing gown, it appears on America's most valuable and celebrated coin, the 1804 silver dollar. (With thanks to Thomas O'Mara.)

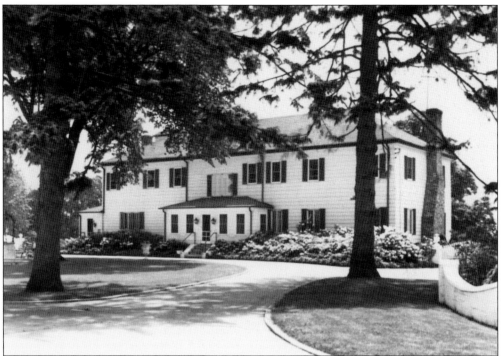

Later views of Bingham Hill portray change. This 1950 photograph of the north elevation has a wide, enclosed porch in lieu of the earlier narrow open porch seen in *Rumson Vol. I*, p. 112, *c*. 1900. The landing windows on the main stairs have been expanded. The entry was inadequate for a fine house, prompting present owner Allan Sockol to add a grand, Post Modern, pedimented and columned entry porch.

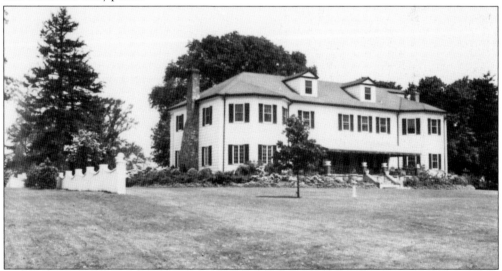

The footprint of the south elevation may be attributed to William Bingham, the late nineteenth-century owner, in view of the presence of the octagonal wings. The porches present *c*. 1900, as seen on p. 112 of Volume I, are gone, replaced by a later porch spanning the wings. The house is recognizable today from this 1950 image, although tennis courts are now on the south lawn. (The Dorn's Collection.)

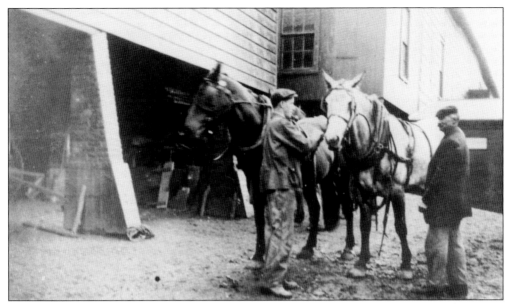

This early-twentieth-century image of unidentified Parmly farm workers and their team helps to portray the working side of Rumson in a volume where farm images are outnumbered by those of riding and polo horses.

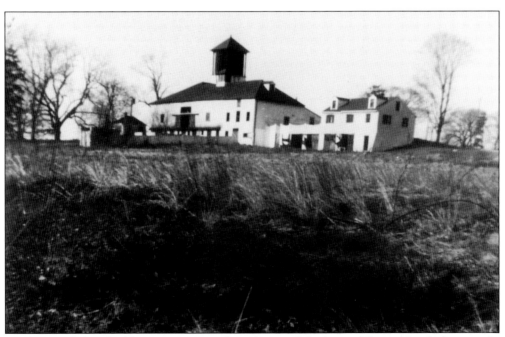

Bingham Hill farm buildings were grouped northwest of the house. This undated photograph, perhaps *c.* 1940s, appears to be the barn with the water tank.

One wonders what accounted for the thinness of this Parmly calf, seen perhaps in the 1920s.

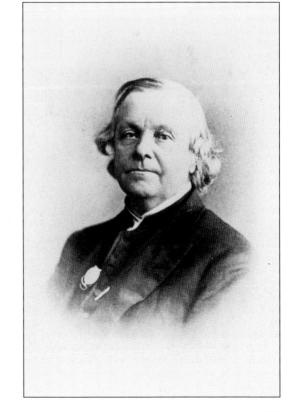

The Reverend Wheelock Parmly, born
1816 in Vermont, spent his youth at
Rumson. He graduated from Columbia
in 1842, studied theology at Madison
University, and was ordained a minister
in 1845. Parmly was long pastor of the
Baptist church on Grove Street, Jersey
City, holding emeritus status when he
died in 1894.

This early-twentieth-century view of a Parmly horse shows construction details of a Bingham Hill barn, which was likely built in stages.

The Parmlys are driving on the beach c. 1915. Lillian Parmly is on the left.

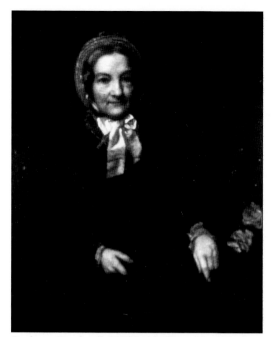
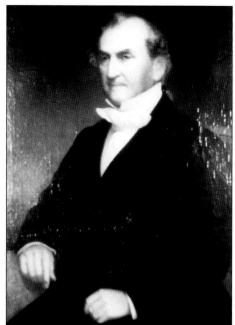

Seabury Tredwell (1780–1865), a New York merchant, purchased his Rumson tract in 1832 and 1833. His wife, Eliza (c. 1797–1882), bore eight children, with the youngest, Gertrude, surviving to 1933. His undated portrait is by an unknown American artist. Eliza was painted by American Jeanette Loup in 1879. The paintings are in the collection of, and the pictures courtesy of, the Merchants House Museum, New York.

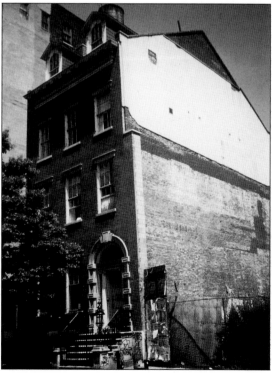

The Merchants House Museum is the 29 East 4th Street, New York City, house of the Tredwells. The Federal-style building with Greek Revival elements was built c. 1830 by Joseph Brewster. It was occupied by Seabury Tredwell in 1835 and remained in the family until his youngest daughter died there in 1933. It is open to the public and conducts various programs. A visit will enhance and enrich one's understanding of and appreciation for a significant historical figure shared by New Jersey and New York.

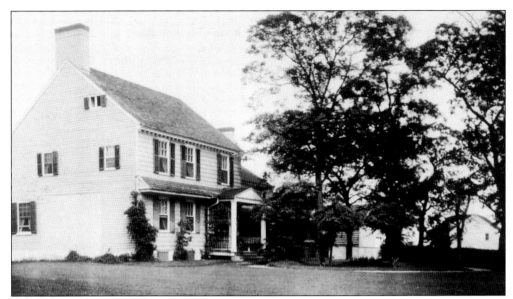

The Georgian-style main block of 16 Ridge Road, also seen on p. 104 of *Rumson Vol. I,* is viewed in a 1920s image looking east. Shutters have been added and a window opened in the northwest corner since the earlier view. This side is the site of Harry Caesar's *c.* 1930 living room addition. Tredwell owned much of eastern Rumson. His estate began a ten-year sale of land in 1882, beginning with the north side of Rumson Road. It held a well-publicized auction for lands primarily on its south side in 1890.

This view is the east wall of the main block hall showing the interior juncture with the older east wing's dining room. The closed door would open to the staircase, offering strong evidence the two sections were joined. The ceiling height is 85 inches in the dining room and 106 inches in the hall.

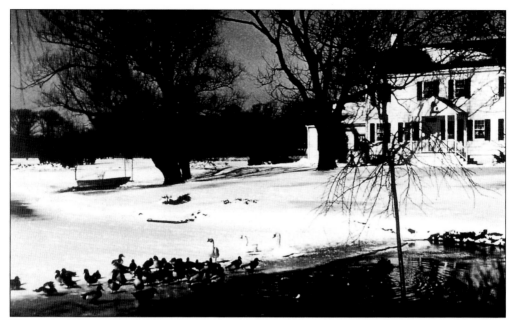

The origin of the Tredwell farmer's house at 2 Ridge Road is the three bays to the west (or left side), a Georgian side hall plan built in the eighteenth century. The early-nineteenth-century addition on the east is harmonious with the original, creating a first impression of a Georgian center hall house. Other changes have been sympathetic to preserving the facade view of this well-preserved part of the Tredwell estate. Fine mirror-image reflections of the house can often be seen in the pond. The late John J. Mulhern, a skilled photographer, made this image in the late 1930s.

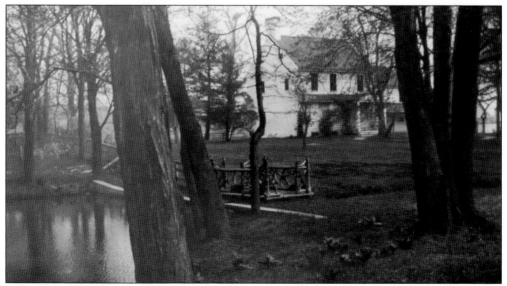

Taken from the same perspective as the image on the top of p. 110, this view, dating c. 1900, shows the still-present siting—well back from the street, adjacent to a brook. The house, with a long history prior to Tredwell embracing the Morris, Saltar, and Hartshorne families, is one of the two most historically significant in Rumson. (Collection Monmouth County Historical Association.)

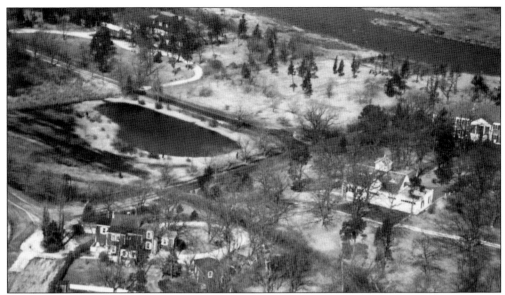

Black Point, the northeast section of Rumson, was one of the earliest settlements on the Red Bank-Rumson peninsula. The name survives on a street, Black Point Horseshoe, visible at left, the address of the three illustrated houses at numbers 27, 21, and 17 (from left to right at the bottom). The latter commands a hilltop with a fine view of the surrounding rivers. This Colonial Revival house was built in 1936 by Leander W.T. Coleman on the site of an old house substantially damaged by fire in 1934. (The Dorn's Collection.)

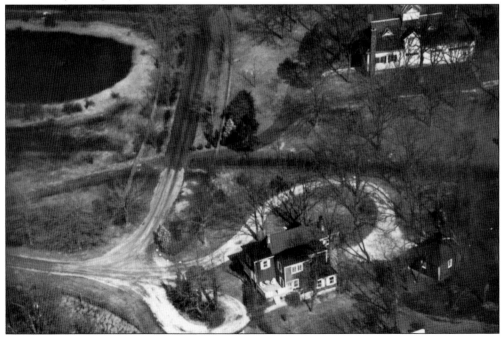

Numbers 27 and 21 Black Point Horseshoe are seen closer in a second 1953 aerial. The garage at top has been remodeled and expanded as a residence. The house at bottom appears to be of undetermined nineteenth-century origin. These houses are part of a large tract purchased by Washington Tyson c. 1870.

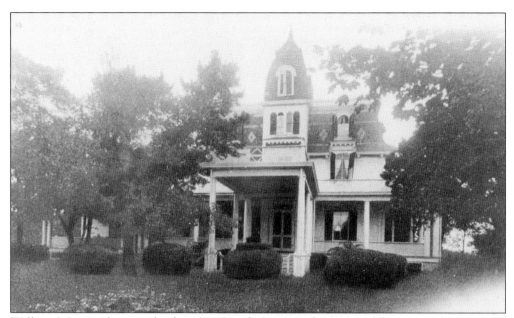

William J. Leonard reported in his 1903 *Seaside Souvenir*, the source of this image, that "In 1885 the late Morton Schrenkeisen purchased the Devoe property at Black Point, where he resided for many years. It is now known as Shrewsbury Park, the property of Col. J. B. Hughes of New York, whose improvements have been extensive and admirable." His estate sold to Joseph B. Hughes in 1901. This appears to be a *c.* 1870s photograph. The house was later bought by Edgar Knapp.

Edgar A. Knapp, born 1877 in Elizabeth, New Jersey, was a graduate of Pingry School. He captained the Elizabeth Athletic Club's 1896 football team, making the only touchdown against Yale that year scored by an athletic club opponent. Knapp was a member of Roosevelt's Rough Riders, seeing action in Cuba during the Spanish-American War. He was a member of many organizations, including Squadron A of the New York National Guard, the Sons of the American Revolution, the Down Town Association, and the Rumson Country Club. Knapp was active in Republican politics and the insurance business in New York. He died in 1945, a few months after his son was killed in action.

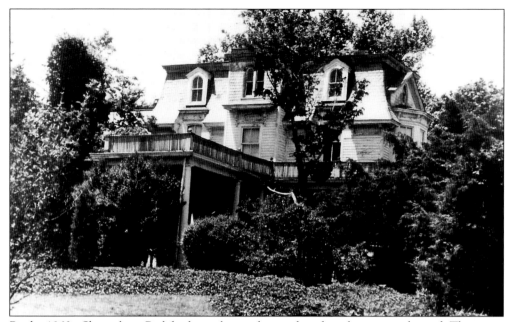

By the 1960s, Shrewsbury Park had seen better days and its demolition was planned. The tower was removed at an unspecified time. The estate was on the west side of Navesink Avenue, on the Navesink River.

Around 1936, John Carter, shown here age twelve, found the pond equivalent of "Jaws" on Knapp's estate. He pulled the 30-pound creature out with some difficulty. Knapp hung it for display, suspecting it as the predator that had been ravaging his ducklings for years. An eighty-year-old fisherman named Rogers identified it as a deepwater head fish, also known as an ocean sunfish, and estimated it to be fifty years old, suspecting it may have been dropped by a fish hawk when young. He was curious about its death, braved the sharp teeth by reaching into its stomach, and pulled out an eel. He suspected that this poor choice of dinner did considerable damage before expiring inside the fish.

Edgar A. Knapp Jr. enlisted as a cadet in the Army Air Corps in December 1942. He had graduated from Westminster School at Simsbury Connecticut and was employed by the Monmouth Lumber Company. Knapp was commissioned a second lieutenant in May 1944 after pilot training at Nashville Tennessee. He piloted a P-51 Mustang fighter plane with the 364th Fighter Group based in England, with bomber-escort and ground-strafing duties. Knapp was killed in action in 1945.

Knapp's daughter Elizabeth raised horses, including the racer Elegant Nell.

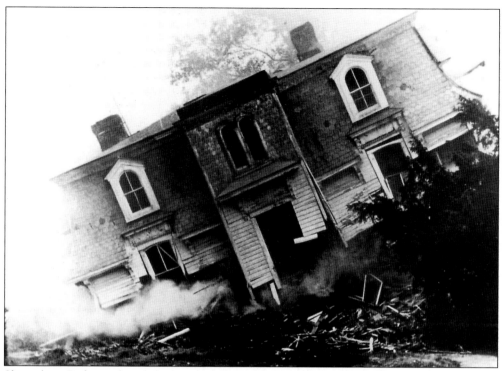

Shrewsbury Park was demolished in the late 1960s. A new house is on the site now.

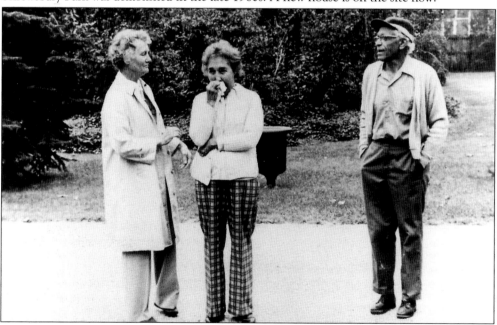

Ruth Carter (center) and John R Carter, parents of the picture lender, Bobbi Carter Campbell, and members of the household staff, were photographed at the demolition of Shrewsbury Park. She was visibly upset, while he seemed to understand that tomorrow was going to be another day. Bobbi pointed out that staff workers often expressed a high concern for their properties as it was the center of their existence; they often spent more time at home than the owners.

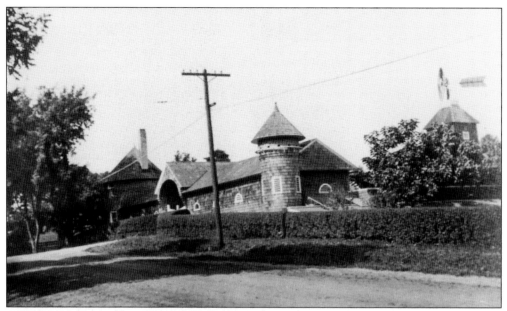

Solomon Loeb owned a substantial estate running south and east from Buena Vista Avenue and Ridge Road. Christopher D. Chandler's September 18, 1910 photograph of the Loeb dairy barn will require further research before the location of the dairy barn can be pinpointed; it was possibly on Buena Vista, as little of Loeb's estate remains.

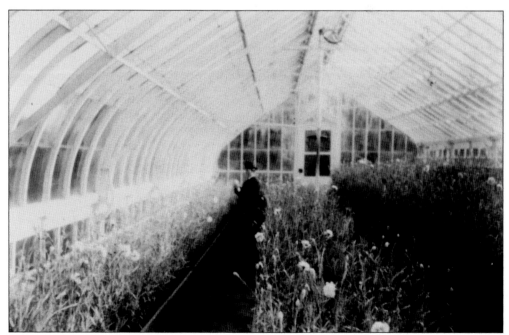

Loeb had several outbuildings. Christopher D. Chandler not only marked this one as his carnation house, but the noted Fair Haven photographer and postcard publisher indicated this November 1, 1908 picture was the first taken with his new 5-by-7-inch camera.

The Auldwood gate was possibly the finest erected in Rumson. This image, perhaps 1930s, shows a glimpse of the Tudor Revival home of Joseph C. Hoagland. Although the house was demolished for development in the 1940s, the gate still stands on the west side of Bellevue Avenue, between Ridge and River Roads. (The Dorn's Collection.)

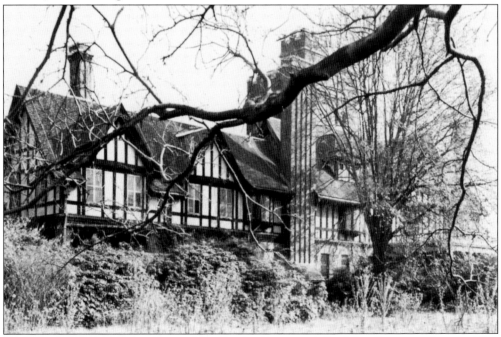

Auldwood is an 1892 house designed by Shepley Rutan and Coolidge, Boston architects. This image reveals that the tower faced east, with a closer view shown on p. 100 of Volume I. The image of the west elevation is undated, but was probably taken close to its 1947 demolition. (The Dorn's Collection.)

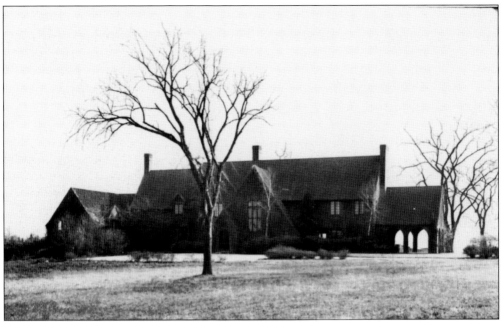

This unidentified image was part of a group of the Hoagland estate. One is tempted to attribute it as 21 Bellevue Avenue, an extensively altered house built by a son of Joseph Hoagland. However, the present house and this 1940s view do not easily "fit," so further research is required. (The Dorn's Collection.)

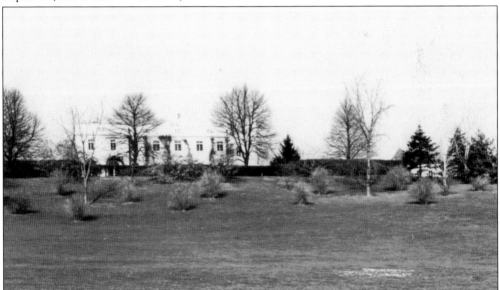

A third Hoagland view from the same group shows an unidentified farm structure. Raymond and the younger Joseph Hoagland established a stock farm, raising horses and dogs. The family attempted to accumulate an extensive riverfront tract to establish a community that would embrace the present eastern Fair Haven and western Rumson. The once-extensive estate has been developed, a condition hindering photographic study. However, publication of tentatively labeled images of the recent past often produces an old-timer who remembers the scene. (The Dorn's Collection.)

119

This *c.* 1950s aerial looks south, from the intersection of Ridge and Fair Haven Roads, with the Rumson Country Club in the background. The McCarter barns, also seen below, are in the upper left corner. Across from them is the Edwin Stewart house (Volume I, p. 53). West (to the right) of Stewart are houses that at various times have belonged to Henry Atha, George A.H. Churchill and A.W. Long. (The Dorn's Collection.)

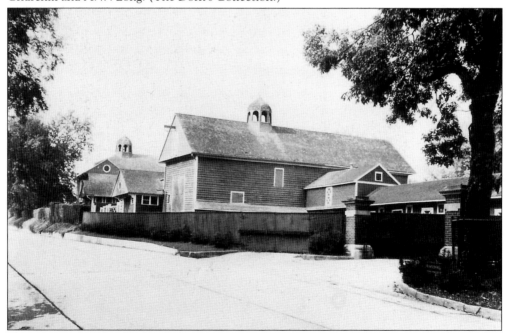

The location of this *c.* 1940s image looking north on the Fair Haven Road is easy to identify, the absence of the McCarter barns notwithstanding. The gate posts remain, leading to Rumson Hill's farmer's house (Vol. I, p. 107) at 15 Fair Haven Road.

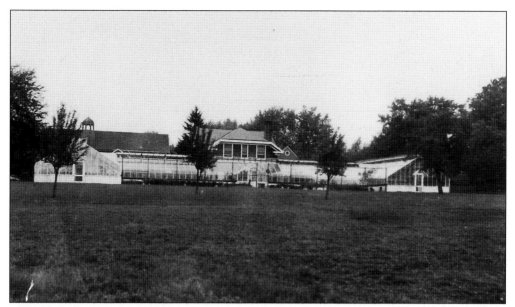

The McCarter greenhouses, located east of the barns, were reported to have been moved to a Colts Neck location c. 1946. Their origin is not certain as the prior owner of Rumson Hill, Edward Kemp, also had greenhouses. However, McCarter built at least one large greenhouse contemporary with his residence.

Rumson Hill's driveway became Sycamore Lane after development. Thomas McCarter built a network of stone roads at the time he built his house.

Three pairs of brick gateposts marked the entrances to Rumson Hill. They survive, this pair on Rumson Road.

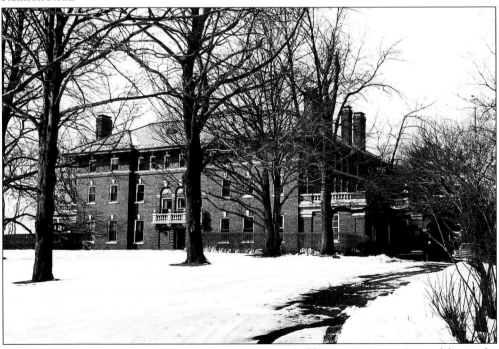

Warrington G. Lawrence designed this three-and-one-half-story Georgian Revival house for Thomas Mc Carter, begun in 1905 and completed in 1907. It was built on an elevation south of the location of the demolished Kemp house, creating a visual impression of greater height. The north elevation is seen on p. 108 of Volume I, while this early 1950s image is of the south elevation. (The Dorn's Collection.)

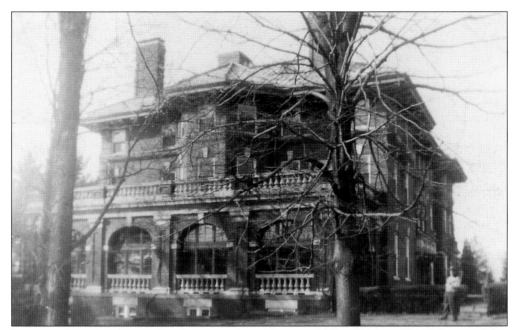

Lawrence Low, a real estate developer, purchased Rumson Hill *c*. 1954, and lived there with his family for about ten years. He demolished the old house for development *c*. 1964. This *c*. 1950s image is of the west elevation.

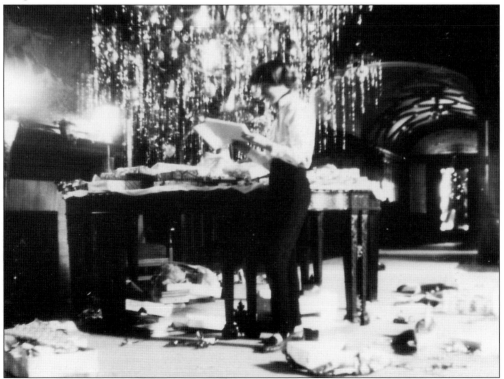

Patti Low Stikeleather, seen on a 1950s Christmas morning, recalled Rumson Hill as an exciting site for holiday celebrations. The tree was placed on the large table in the hall.

The 1915 McCarter Bridge is most likely recalled covered with grafitti rather than the ivy in this *c.* 1940s image. It has been said that graffiti, which began as an expression of school spirit and only later attracted odd writings, was allowed on the bridge with the understanding it would be tolerated nowhere else. Although the police did not vigorously patrol for artist-trespassers, they were regarded as a safety hazard to themselves and to motorists passing below and some found themselves unceremoniously taken away. The road was later widened, at least by the removal of the sidewalks. However, the arch was not designed for modern traffic and the bridge was removed as a safety hazard in 1988.

Yes, even vehicles of moderate height could pass only by crossing the center line—not a safe gesture. The 10 foot, 6 inch clearance was modest, indeed. There were a number of accidents. Perhaps public fears were not raised for small truck accidents in view of the bridge's charm, but the crash of a senior citizens' mini-bus created a concern that concluded with the bridge's demolition.

Helen M. Kirk Wagner (born 1900), with appealing long hair and attractive dress, is seen perhaps at her graduation from business school. She died in 1973.

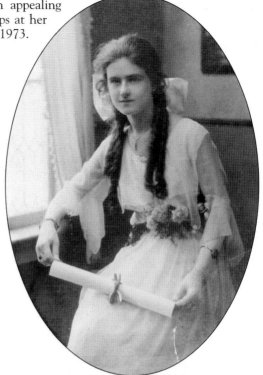

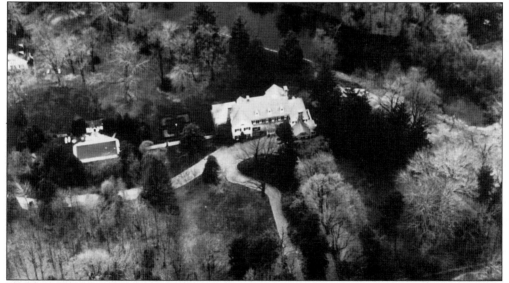

C. Alan Hudson, who studied architecture at Columbia and engaged in the antiques business, built this large Colonial Revival house at the southwest corner of Buena Vista Avenue and Ridge Road in 1934. The design origins may be varied. Hudson had a part, while Red Bank architects J.C. and G.A. Delatush supervised construction; the author has also seen references to work by a major New York firm. The house, reported built in a 66-by-56-foot "L" shape, probably has later additions. Its corner plot has been reduced, with newer housing built, but the house's siting remains one of Rumson's most attractive.

Jane Clayton, with early business experience in the family institutional grocers Eugene and Company, is best known as a county official. She was the first woman to be elected freeholder, in 1976, and after serving one term, she won election as county clerk in 1979. Seen in her clerk's office in 1982, Jane was re-elected in 1984, 1989, and 1994, retiring on December 31, 1996. Jane's accomplishment with the greatest public profile is the establishment of the County Clerk's Archives, a state-of-the-art facility built within the County Library.

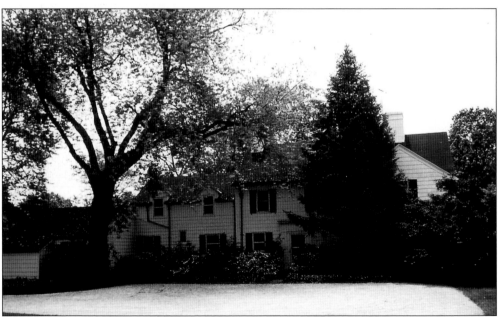

Georgette, widow of Dr. Ernest Fahnestock, moved to Rumson after selling their famed Shrewsbury estate Shadow Brook in 1942. First owning 101 Rumson Road (p. 65), bought in 1944, she later that decade moved to this house at 21 Bellevue Avenue, designed by her son, Edward Ritzma Perry, and resided there until her death at age eighty-three in 1957.

Edward Patrick Walker, better known as Mickey, was born July 13, 1901 in Elizabeth, New Jersey, and he began his boxing career there in 1919. Over a seventeen-year career, he won ninety-three bouts, sixty by knockout, and lost nineteen, with four draws. He held two championships: welterweight from 1922 to 1926 and middleweight from 1926 to 1931, failing in a 1929 effort to add the light heavyweight crown. His massive size for his weight led to his nickname of "The Toy Bulldog," a label to which his looks only contributed. "The Mick," a brawler of a fighter, also lived hard (with seven marriages to four women), and drank hard (calling himself his bar's best customer). He died in 1981, after having moved away from Rumson. (Collection of John Rhody.)

Mickey Walker
Middleweight

The stem of Ridge Road approaching the border with Fair Haven at Hance Road seemed rural in 1954. Development occurred in several places, notably at the southeast corner where the Congregation B'Nai Israel completed its synagogue in 1958 (see *Rumson Vol. I*, p. 124).

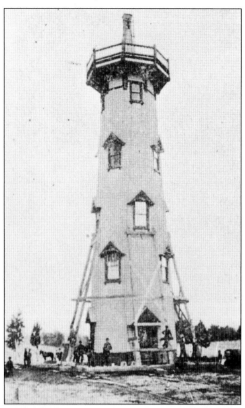

The Navarro water tower, 80 feet high, 20 feet wide at the base, and weighing an estimated 60 tons, was moved in 1892 by Ambrose Matthews Jr. of Red Bank. He had to post a $4,000 bond for damage. The tower was raised and three heavy timbers were placed underneath. Thirty-foot braces were fastened to the tower and timbers. A large crowd, including the tower's builder, Corcoran, watched the event be completed without mishap.

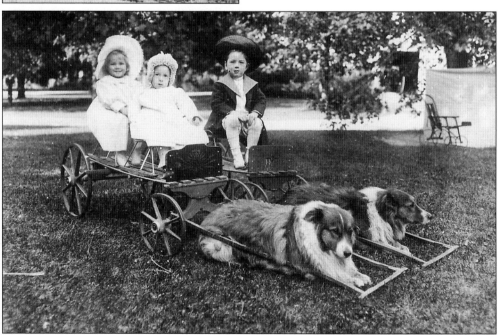

So, the author likes to close his *Images* books with a goat cart, and this happens to be a dog cart. But, can one expect to find a finer dog cart? This example was photographed on the Borden estate *c.* 1915.